NORTHUMBERLAND
CHURCHES

From the Anglo-Saxons to the Reformation

Stan Beckensall

AMBERLEY

ACKNOWLEDGEMENTS

I am very grateful to Graham Usher, the Rector of Hexham, for the Preface; to Kim Cowie for checking the text; to Marc Johnstone for the map and to Tony Iley of *The Hexham Courant* for his aerial photographs. The other illustrations are mine, taken over a long period of time. I thank the University of Newcastle for the Rothbury Cross illustration, and my son, Julian, for help with the computing.

I am also grateful to my editors, Nicola and Tom, at Amberley.

First published 2013

Amberley Publishing
The Hill, Stroud
Gloucestershire, GL5 4EP

www.amberleybooks.com

British Library Cataloguing in Publication Data.
A catalogue record for this book is available from the British Library.

ISBN 978 1 4456 0436 7

Typeset in 10pt on 12pt Sabon.
Typesetting and Origination by Amberley Publishing.
Printed in the UK.

CONTENTS

PREFACE

Our churches are a significant part of this nation's treasure trove. Each is a jewel and none more so than those in the county of Northumberland. When you look closely at a jewel you see light, texture and colour all working together to form something precious. The same is true of our churches and the stories that they contain.

Their sacred walls seem to whisper tales from their stores of local history – an inscription here, a carving there, a precious object lovingly dusted, or the marks of the changing fashions of liturgy and national religious life. Outside, amongst the dead, we go on remembering our forebears as we catch glimpses of the stories of both the high and the lowly lying side by side under varied tombstones.

Churches mark stories in our own lives: moments of joy celebrated; the times of tears acknowledged; vows made and kept; the annual passing of the seasons and the pattern of the years going by. Whether it is well-sung hymns and crafted prayers, engaging sermons and long, echoed silences, or hands held to receive bread and lips poised to touch the cold-silvered chalice, all help to remind us about how our life connects with that of Jesus of Nazareth.

At the heart of each of the churches that Stan Beckensall carefully describes is the pulse of the God of faith, hope and love. God is silently waiting on us as the church door creaks open and we step inside what can so often feel like a different quality of space. In that brooding waiting is an invitation for us to add our 'yes' to God's 'yes' and so add a page of our story to his.

This is what happened to Oswald, Cuthbert, Aidan and Wilfrid, and that myriad of countless others who have gone before us as pilgrims on the way. I hope that this delightful book, written by a man whose own faith has long been nourished by the example of Northumberland's great saints, will encourage you to encounter these holy places and the stories that are woven into them.

The Revd Canon Graham B. Usher
Rector of Hexham

INTRODUCTION

The earliest Christian churches in Northumberland are usually termed 'Anglo-Saxon', though the tribes that actually settled here are 'Anglian'. None is in its original condition, as the story of churches is one of change, many being subject to the adoption of different doctrines, architecture and internal fittings.

Christianity was first introduced under the Romans; at Vindolanda there is a possible Christian church. But the spread of Christianity comes mainly in the Anglian period, when the invaders from Northern Europe had finally settled instead of raiding and plundering. Northumbria became a base and front-line power in the spread of Christianity, not only in Britain but also in Europe. The centres of this movement were monasteries, and places like Jarrow and Holy Island had a key role to play in producing not only missionaries but also the books vital to such learning.

The quality of scholarship was backed by a revolution in art, for buildings and books were seen to be essential to the spreading of the Word. In early Anglo-Saxon times there was fierce competition between pagans and Christians, a struggle for hearts, minds, and people's lives. One element in persuading people to believe in the power of God was to spread the word about the miracles done in His name, so accounts of the history of the English Church are liberally spread with accounts of miracles. Pagans believed in magic; accounts of miracles were a way of showing that Christian magic was stronger. Churches were built, often on destroyed pagan sites, so that the idea of 'sacredness' continued. The buildings were there to impress and their furnishing to inspire devotion. Paintings and sculptures based upon the Bible were visual aids for an illiterate congregation. Stone churches were unlike anything the local people had experienced; the rich interiors were built and furnished to inspire awe and reverence. A special inclusion would have been relics of a saint, providing strong magic that linked good people to Heaven through the lives of even better saints, who could intercede for them before God's throne and save them from Hellfire.

Some local historians used to assume that places with an Anglian name might have had a church there and that it had been built of wood. This is only true if there is evidence, and usually there is none. Most early Anglo-Saxon buildings were made of wood, and the design of some early churches is based upon a wooden structure, but we have only stone features that have survived in Northumberland, so speculation is not very helpful. There is an impressive scatter of churches with Anglo-Saxon features. As a result of the turbulent history of this border region – Anglo-Scottish wars, the devastation of Henry VIII's Dissolution of the Monasteries, and subsequent religious upheavals, repairs and rebuilding – there are in these churches layers of time, and a history to be read there.

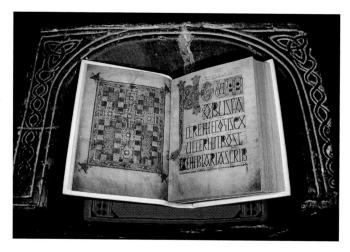

The Lindisfarne Gospels: a page facsimile of the book on the Frith Stool at Hexham Abbey.

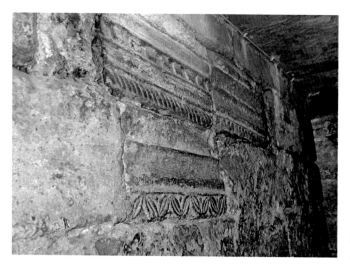

Recycled Roman stone: Hexham Abbey crypt.

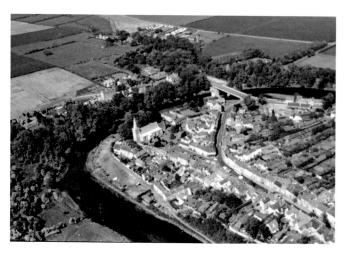

Warkworth from the air. The church is on the riverbank in the middle of the picture.

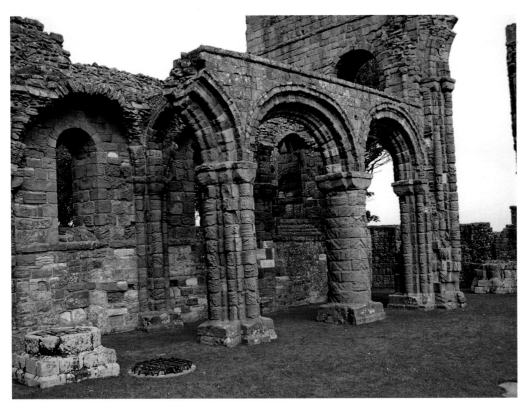

Above: Lindisfarne priory church, north nave, Norman pillars and arches.

Right: Brinkburn priory church east end.

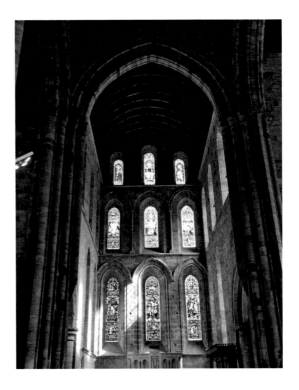

Those churches built near the Roman wall, as well as non-religious constructions, took advantage of the Roman work 'of giants, crumbling' as a quarry of ready-made shaped stone. This element of recycling is a strong feature that we need to take into account by examining carefully all the stones built into a church. We must not be surprised to see recycled gravestones similarly built in.

A major change in church building took place with the Norman Conquest. Northumberland was laid waste by the Normans, but eventually William's followers were rewarded for their brutality and loyalty by taking over great swathes of land. Their castles announced physical power over the local people; their churches stamped the land with their spiritual domination. This was an efficient and ruthless regime that used Church and secular power together to establish and maintain itself. Already in Normandy great churches had been built on a 'Romanesque' plan, and the blueprint was carried over the Channel to be applied to the new lords' estates. Anglo-Saxon language gave way to Norman French; to make any progress in this society you had to conform. A great northern symbol of the new regime is Durham Cathedral and the promontory formed by a river was also chosen for the castle. These symbols were highly visible and immensely strong and intimidating. On a smaller scale, Warkworth castle and church were built on a promontory in a loop of the River Coquet in the same period. Durham's dominance is clearly seen in places like Lindisfarne priory and Norham church, where the masons appear to have been the same.

It was the landlords who provided land and money for the construction of churches; the finer the churches were, the more they advertised the lord's importance. Churches and control of them gave the builders the belief that they would be favoured by God for building them and this idea persisted, for many are still the memorials of important people. Fear of Purgatory led many of them to have chantries built, where priests were paid to pray for their souls. The idea that you could buy your way into Heaven persisted, as did the idea that if you were buried close to the altar you were closer to God.

After the Norman architectural period, fashion in church construction was predominantly 'Gothic' or 'Early English' style, and the pointed arch replaced the rounded one. It was revolutionary, and the solidity of Norman building gave way to huge areas of light that spilled into the church through glass windows. This and the following 'Decorated' and 'Perpendicular' periods brought in fan vaulting and geometric variety that is still breathtaking. The huge cathedrals are not the only ones to benefit from this; there were also many parish churches where competition among landowners continued to provide the money, materials and labour to fulfil their dream of creating something amazing. How far the peasants and others shared this pride is difficult to ascertain, but as the church was such a central part of people's lives, it could well have been so. The church was their spiritual centre; for so many it was part of the rhythm of life, a meeting place, a place of entertainment, a place where baptism, marriage and death were celebrated and marked down. We must not underestimate its importance to them, but when doubts began to enter through events like the Black Death, which struck Britain by killing off half the population in many parishes, the authority of the Church was seriously undermined. The Church did not help them in such times, for there was no one to bury the dead. People thought that God had let them down and their priests could not save even themselves.

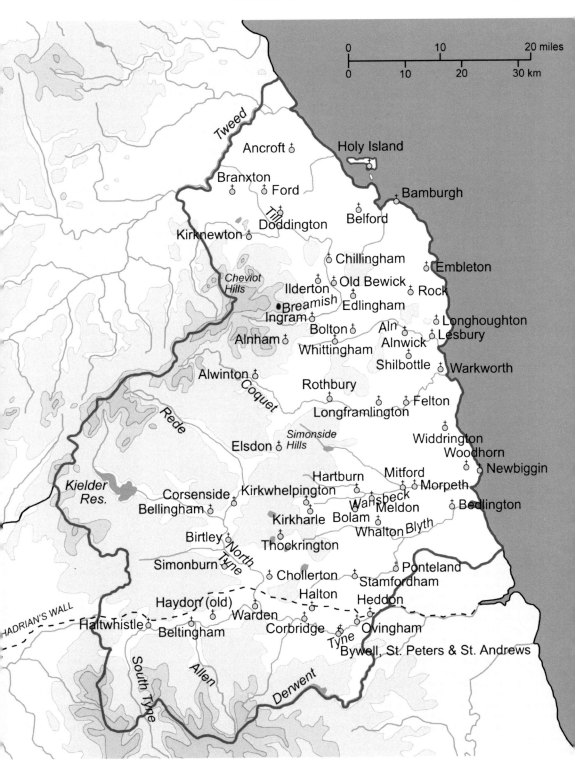

The distribution of churches mentioned in the book. (Marc Johnstone)

The task of rebuilding and repairing churches generally fell to the landowners, giving them power over the parishioners and in the appointment of priests. Churches themselves were witnesses of their power (a marked contrast to some Victorian chapels, which were erected by working people). Religion may have civilised many, imposed a moral discipline and fostered loyalty to village and lord, but differences in dogma also caused great friction. The un-Christian life of some monks may have turned many against the monasteries – a lever used by Henry VIII in his decision to dissolve them, though his main motive was to get his hands on their riches and to become the head of the Church himself in the place of the Pope. Others benefited from this sudden release of wealth once held by the monasteries, and a new class of landowner emerged who had money to buy land and the status that being a landowner brought with it. Once they had this wealth they were determined to keep it. The parish churches remained a central influence in the land without being tied to religious orders, and survived the onslaught of the Reformation. If a monastery provided the only parish church, as it did at Hexham, it was spared destruction, but this was exceptional.

Economic forces also changed the balance of population. The breakdown of village communities when arable land was turned over to sheep-farming, changes brought about by newly-acquired bargaining power of those who survived plague, or the movement away from the country to town, contributed to a shift in the balance of power. Many villages continued to be self-supporting, with a great range of occupations among the people, but some died out completely, becoming 'deserted' and leaving faint traces in the landscape and many traces in documents. The growth of new industries, the reliance upon coal as a source of power, and mineral deposits such as galena and iron, shifted the bulk of the population to the south-east at a great rate. Although churches with a long history were still there, the main result of this was a host of new buildings that suited diverse and manifold religions – a process that continues even when many buildings have become redundant.

I shall not be pursuing this modern period, interesting though it is, because the scope of this book is to show the old churches in their contexts. They may have been radically changed to suit different tastes and concepts, but to trace their history through what is visible is fascinating.

Although this book concentrates on architectural detail, the buildings are only part of the story of Christianity. Stone features have witnessed people's lives, deaths and other 'rites of passage' – warmth within cold stone walls. Architecture reveals that people are aspiring to something beyond the ordinary; buildings enclose lives and history, and so this book is only part of a greater story.

Most churches have been heavily restored, some sympathetically, and contain evidence of many periods. I have chosen some churches to illustrate specific periods: Anglo-Saxon, Norman, Transitional, Early English (Gothic), Decorated and Perpendicular, though many churches may contain many of these. As space is inevitably limited, some churches will be described briefly and without much illustration, which does not make them less important to the people who continue to worship there.

1

THE EARLIEST FOUNDATIONS: THE ANGLIAN/ANGLO-SAXON PERIOD

Northumberland had a crucial part to play in the introduction and spread of Christianity in Britain, and had an influence that was far wider. Holy Island especially encapsulates many of the remarkable achievements of God-inspired monks to convert polyglot populations that made up 'Britain'. From this evangelising mission two strands of influence emerged – the 'Celtic' and the 'Roman' – which competed and were eventually tested for dominance by their meeting at the Synod of Whitby in 664.

In the earliest period when Christianity and the old pagan gods struggled for supremacy, the most powerful contestants strove to prove that their gods or God were more powerful. This is seen clearly in the great attention given to miracle-working, for the supernatural had to be seen to influence people's lives. Stories of the early saints are full of such instances, appealing to the ordinary people who were the majority of the population. For the rulers, the advantages of accepting Christianity may have been less based on miracles and more on their seeing great political and military advantages in becoming Christian. A common element in history is that protagonists like to claim that God is on their side. Without the protection of powerful lords, Christianity would not have succeeded, and without gifts of land and guaranteed income, the monasteries could not have been established. How 'genuine' conversions were is difficult to assess; how can we know much about the motives of such people?

As for the ordinary people, once their rulers became Christian it must have been impossible for them not to follow suit when ordered to do so. How many of the hundreds baptised by Paulinus in the River Glen on the orders of King Edwin had any choice? Anglo-Saxon society was strongly based on loyalty to one's lord, and that included being of the same religion. This may sound cynical; to look at it from another point of view, some of the early 'saints' must have been brave, totally convinced, and skilled in what they set out to do – to preach Christ's word to everyone, with the help of those trained to be their followers. In a world where violence was rife, where the ability to kill others was highly prized, 'saintly' kings like Oswald killed hundreds in the cause before he shared the fate of hundreds of others when his body was dismembered, traditionally at Oswestry (Oswald's tree). There were others – also regarded as saints – for whom military prowess was not the way forward, although they undoubtedly needed such warriors to sustain and protect them.

The great names of Aidan and Cuthbert are just two that spring to the fore in the remarkable lives of these early missionaries and thinkers. Brave people went forward in a world that was dark and threatening, taking their message to the heart of people by example as well as words, seeking converts to their dearly held beliefs. Miracles attributed to them would have been widely known, and their bodies were sought after their deaths as powerful relics, yet in the beginning it must have been a dynamic personality and vivid message that made them so remarkable. In the case of Bede at Jarrow, who recorded the achievement of these evangelists, it was his devotion to scholarship through his chosen vocation and brilliant mind that drew together all the stories of the early church that he transmitted to us, although his writing had to be highly selective in order to emphasise the best that happened in the Church. No warm library for him, but a dim candlelight in all weathers within a stone monastery totally devoted to his research, visited by scholars from all over the world who would learn from him and he from them. He survived when plague wiped out almost all the other monks at Jarrow, and would have done his share of the manual work that was part of his calling. Later pictures of saints, especially on modern stained-glass windows, depict anything but their toughness of spirit and body, and clothe them in impossibly rich robes. It is as though their characters have been airbrushed away in a never-never land.

The early monks of this standing produced the books that spread the Gospel, providing them as works of art, in the belief that only the best was good enough for God. They strove to bring colour and hope to the harsh lives of their people; churches were built not just as meeting places but also as a place where God had his dwelling, where the art on the walls taught them the Gospels, where the richness of furnishings sometimes brought from Europe gave people a glimpse of something higher – of Heaven, if you like. Going into a church was a special experience, quite divorced from the clusters of buildings where people lived their everyday lives. Remember that in an early period even kings did not live in stone buildings; Maelmin and Yeavering, two early royal 'palaces', were made of wood.

If we look at a list of some of the main events of the period 672–793, below, it may help as a guide to how important this early period was:

Some Events in the History of the Early Church

627	Edwin became king.
627	Edwin was baptised by Paulinus at York.
632	King Oswald defeated Penda at the Battle of Heavenfield.
633	Aidan came to Lindisfarne.
642	Oswald was killed.
664	The Synod of Whitby.
670–80	The founding of monasteries at Wearmouth, Ripon and Hexham.
681	The founding of Jarrow monastery.
731–32	Bede finished his history of the English Church.
793	Lindisfarne was attacked by Vikings.

Edwin was the first 'Christian' king of Northumbria, but left the future of the Church undecided after his violent death, despite having had Paulinus baptise hundreds of Christians.

Warfare was endemic, rulers were lucky to survive death in battle or assassination by members of their own families, yet their support for the priests was essential. Missionaries did their job with royal support; Aidan is said to have had King Oswald as his translator when he went among the people!

Lindisfarne came into its own as a prime centre of learning and power, and the conflict between those who supported the Roman Church against the Celtic Church ended in victory for the pro-Romans at the Synod of Whitby. Wilfrid, who was a great champion of Rome, founded such great churches as Hexham and Ripon, and the building of Jarrow monastery became the home of Bede.

It is largely thanks to Bede, a monk who seldom strayed far from his monastery, that we know so much about this early period, as he collected information from everywhere, including those who came to visit him there. His scholarship and power of mind drew together all the stories that he has transmitted to us. We admire the sheer dedication and work rate of people like him, who produced so many manuscripts that spread the Word to others at a time when for so many life was 'nasty, brutish and short', in the words of a much later historian.

This phase of building up the Church may have been accompanied by heated debates about doctrine, but all that was eclipsed by the onslaught of Vikings, who could easily reach and sack coastal monasteries. The coast was no longer safe.

This account is not attempting a history of the Anglo-Saxon Church, which continued to grow with all its conflicts and insecurities until a formidable power – the Normans – by conquest replaced it with its own. On the eve of this conquest, church building continued, and examples survive, until the Normans imposed their own distinctive architecture on England.

Anglo-Saxon Features in Church Buildings

In looking at the surviving examples of Anglo-Saxon architecture, we are going to miss what the interiors and their furnishing looked like, as the buildings that we have are only the shells of what remain. So much has been destroyed or modified that we have to take the fragments to glimpse what might have been.

Some of the most important survivals are in the River Tyne Valley, close to the Roman wall and its settlements, that provided such a great amount of ready-made building stone. Here recycling was logical: why go to the trouble of quarrying stone when the Romans had left so much behind? Some of it was plain, perhaps with tool markings, and other pieces were well-decorated. There were tombstones, window frames, arches, and decorated panels – many ready-made insertions for their churches. There were examples of what could be built out of stone in this new age on the Continent, which many clerics from Northumberland visited, bringing back not only ideas for the buildings but also craftsmen with the skills needed to build them who could be tempted to help.

If we look at churches primarily in terms of structures we may miss all that was generated inside them, reflecting all the stages of life from birth to death and, hopefully, resurrection. They warned of the perils of Hell, but rejoiced with those who had gone to join the saints. We know that where stone churches did not exist there were ornamental crosses that became a focus for worship and learning, as fragments of these have been found, but the churches

would have been outstandingly visible with their tall, thin towers, long naves and rounded (apsidal) east ends. Escomb in County Durham is often taken as one of the finest surviving examples. Those in the Tyne Valley that have more-or-less intact Saxon towers may have little else, and trying to understand what the overall effect of the church would be is often helped by making comparisons.

We begin not only with the towers, but also with what they were made of, and this is where the recycled Roman stone is evident. Firstly, the small blocks taken for the wall are a standard size. Secondly, some stones still bear Roman inscriptions or decoration. Thirdly, the engineering techniques, such as making a slit (Lewis-hole) into which a spring wedge is inserted and released, enabling the Romans to lift them with a crane, are still visible.

The tower was built with thin walls, unbuttressed, tall and narrow. Many examples follow. The nave would have been without aisles and end with an apse. It is possible that early graveyards around the church would have been circular or oval. Very little remains of furnishing and decoration, but there are fragments of crosses and some ornamental work that give an indication of what is lost.

These towers can be seen from a distance, but there is one building where the survival lies underground: the crypt at Hexham Abbey. As this tells us so much about how it was built, the symbolism of its plan and how it was used, this will be my beginning.

Hexham

Hexham crypt and the crypt in Ripon Cathedral, both built by Wilfrid, are unique in the North. Recently, at a Hexham Abbey Christmas fair, I was asked to be a guide down through the crypt. People generally come for miles to see this. There was a constant stream of people in groups all day, going down thirteen steep sandstone stairs, of which the top three are modern, into the bowels of the earth. What struck me about their reaction was how impressed they were, young and old, by the awesomeness of it. The idea of opening it up during a fair was a good one, for people who may otherwise have found the abbey daunting and 'not for them' came in. Some confessed that they had lived in Hexham for years and never been in the abbey, let alone the crypt. How different from a church in medieval times, when it was the centre of life for the village. The experience of going into the crypt today must have been a little like that of pilgrims in the past.

The crypt was not a place for burial, but it was for the display of relics. Its plan is thought by some to be based largely on the temple at Jerusalem and the Roman catacombs. It is certainly of a rare early Christian type. Wilfrid's visits to France and Italy gave him many ideas about building in stone, and the building of Hexham church was acclaimed by people of the time as the finest north of the Alps.

If we followed the Anglo-Saxon pilgrims, we would enter the crypt to the north-east by a spiral staircase. We would turn left, then sharply right along the longest of the narrow corridors, which was made of Roman stone. The floor was uneven, the way dark and narrow – like our journey through life. We would have been ushered along because there were so many behind us, until we turned left and found ourselves in an antechapel (or vestibule) that gave access to a rectangular room with a semicircular barrel vault made of wedge-shaped stones that flickered with lights from three niches in the walls. In this little room we would view the

sacred relics, to which we attributed great power, from the doorway. The lack of space and the press of pilgrims behind us in the tomb-like atmosphere would have been countered by the knowledge that we were promised resurrection, which was what this illuminated chapel signified. From there we would have made our way up the steep stairs to the nave and altar above. Those who served the church could have entered or left through another doorway that led to a shorter southern corridor and a spiral stairway. There would have been a continuous movement of people coming in and going out.

Today people can spend a little longer than these pilgrims and have the chance to examine the building in more detail. The plan and photographs help here. Charles Clement Hodges, the architectural historian of the abbey, introduced the Saxon period to us in 1893 like this:

> Fraught as it is with a degree of mystery and obscurity exceeding that attached to many kindred investigations, there is yet enough that is certain to lead the inquirer, who has the patience to search all sources of information, and examine all the remains of masonry, to form conclusions regarding the form and arrangement of the churches of this period, of the correctness of which there can be little doubt.

However, there are enough disagreements to challenge his word 'correctness'.

Fortunately the crypt remained buried for hundreds of years, long after the church above it had been replaced, and is remarkably intact. We have documents, too, like one by Eddius who describes Hexham's great crypt and subterranean oratories (places of prayer) with many passages and branches beneath the floor. We have descriptions that tell us what kind of building the crypt supported, for the church had been built of squared stones and well-polished columns. There were relief decorations carved on the stone and there were pictures and paintings. There were aisles and porches on every side linked by winding stairs in stone towers at three levels. Relics, treasures, fine vestments and books helped to make this an exceptional and magnificent church, but it is the more austere crypt with its thickly plastered walls that remains.

Where plaster has fallen off we see the extent of recycled Roman stone. There are large blocks, like those forming the stair to the nave, slabs forming the ceiling, smaller squared ones, and thin strips of decorated stone that are echoed in others displayed in niches and on the walls in the modern nave. One roof slab in the north passage is a building inscription naming three emperors – Severus, Caracalla and Geta – dated 205–08. Another inscription, on a slab re-cut as a door arch, is dedicated to the god Maponus Apollo. Some doorways appear to have their tops built of ready-made stone taken from inside Roman buildings. The bridge over the Tyne at Coria, where the remaining stones have recently been rescued from flooding, was also a source.

There have been suggestions that the choice of Roman stone was made because Wilfrid was avidly pro-Roman, but this is unlikely, as masons would have found the local material ideal, it being ready-made. Any dedicatory Roman stones were used for another purpose. Flat stones cover the upper part of the crypt, which lay not far below the nave floor. The famous Flavinus memorial from Coria, used in another part of the building as a foundation, was found face-down.

The main part of the Saxon church, the nave, suffered abandonment and decay that left the church looking maimed for centuries, with the later transepts and chancel remaining. When

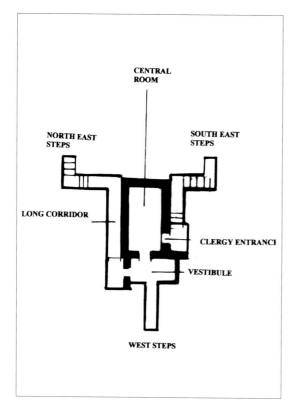

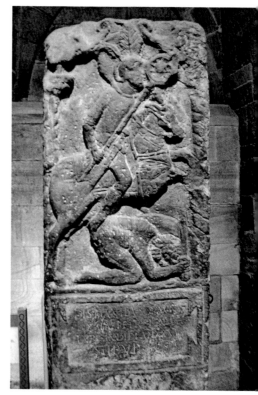

Above left: A plan of Hexham crypt.

Above right: Flavinus memorial from Coria at Hexham priory church.

the work of modern rebuilding began in 1904–08 there was an opportunity to look below the surface, and there have been more recent examinations. However, it is still difficult to match the archaeology with early description; this has been complicated by the difficulty of distinguishing Saxon from post-Conquest building. The monastery/cathedral was sacked by the Danes in 876, and we know little more until it was refounded by Augustinian canons as a priory church in 1113. A medieval nave on the same site was destroyed too and the site became a graveyard for townspeople, and all this turbulence does not help us to build a clear picture of such structures. There have been many disagreements among architectural historians. However, it is possible to say that above the crypt the nave was over 35 metres long with aisles on either side. One strange feature is that the west entrance of the crypt is not central to the crypt chapel where it enters the vestibule. According to Symeon of Durham, the nave ended with an eastern apse. It is located in modern times with tombs around it, but this is not proved to be the original one. It was possibly an independent chapel, a sanctuary or a second crypt, which only deeper excavations can confirm. The Normans built their apse further to the east. Apart from pieces of worked stone, the rest of our knowledge of the early church is from documents. There are many pieces of Roman sculpture, presumably reused by the Saxon builders, but also there are some fine pieces of Anglo-Saxon work, some of which were brought from outside the present abbey.

The building of the church and monastery must have used a considerable amount of stone, so what happened to it all? It would seem logical that it would be reused in later building, but a lot of that building uses stone quarried from elsewhere, much of it Millstone Grit. Could it be that other buildings in Hexham, such as the Moothall and Old Gaol, made use of it? There are many other unanswered questions for the future.

What appears to be reasonably clear is that the church had a nave flanked by aisles, two small transepts, an apsidal chancel, towers with spiral staircases that led to other storeys, and a number of entrances other than the main western one. It was the focus of monastic buildings that included a cloister. Here people lived and were buried to the south of the buildings. In 1990 my limited excavations in a trench dug for new BT cables revealed that the lowest layers of burial were of un-coffined people lying on their sides with their faces to the south and their arms by their sides. These may have belonged to the earliest foundation. Other Anglo-Saxon burials and grave slabs appeared when the foundations for the modern nave were being dug.

The monastery, which became a cathedral, was a vital part of early Christianity, but there are accounts of other churches on the town site. Fronting the Market Place is a rectangular medieval church, which is reputed to cover another of Wilfrid's churches in honour of the Virgin Mary, but despite some glimpses below the surface, this older building has not yet been found. Another church, dedicated to St Peter, at the east end of the Saxon church was probably absorbed by it into one building. Without the power and influence of Wilfrid and his initial persuasion of Queen Etheldreda to grant him land for it and income to support it, none of this would have been possible.

Among the interesting pieces of decorated Saxon stone now preserved in the abbey and at Durham Cathedral there is a stone bishop's throne (cathedra) that has been broken and

The 'cathedra', a bishop's throne at Hexham, also called the 'Frith (peace) Stool'.

patched up during one of the many restorations of the building. It is often referred to as Wilfrid's and is probably from 675–700 – a rare piece of sculpture.

The land on which this early building stood was given to Wilfrid by Queen Etheldreda, and such 'royal' land was unlikely to have been a wilderness. The Tyne Valley floor would have been rich arable land; there may have been small clearings in forests bordering on moorland, and there would have been an abundance of wild and domesticated animals, hunted or tended by small, local groups of people, and there would have been plenty of timber – an essential resource for any Anglian community. A monastery needed income to support it, and this was in the form of the land and its products, not only nearby but also in distant parts of the country. A gift of land could have brought peace of mind to the donor.

I shall look at later developments of this site and its church further on in the book.

Tyne Valley Towers

Rivers are important means of communication, and their crossing places were either fords or bridges, where settlements tended to grow. Tall towers would have acted as an important landmark; in these early times they were thin and without buttresses.

The first example west is St Michael's, Warden, where the importance of the site is attested by the finding of flint and quartz chippings and tools that go back to the earliest settlers in the north – the Middle Stone Age hunter-gatherers who camped on the sunny south-facing slopes of the riverbank during the spring and summer months before returning to their coastal settlements in the winter. In much later prehistoric times, the pre-Roman Iron Age folk built a large enclosure on the top of Warden Hill, which was a meeting place for scattered farmers and a defensive site. Their farming would have included growing grain and domesticating animals. Some of their terraced fields remain, used by generations as arable land. The hill and its slopes were not, however, favoured for the building of an Anglian church; this was built on the fertile 'haugh' land that was established by the river's floodwater in geological time. It is quite flat, so the tower rises impressively from it.

Today the church is multi-period, the earliest part being the Anglian tower, made in its lower courses of Roman stone. One strong characteristic of this early building is the size of the corner stones, the quoins, which hold the tower together without the need for buttresses. These often alternate in thickness, leading to the sophisticated 'long and short work' seen further south, but also present at Whittingham (described later in this chapter). Such stones were readily available from Roman sites not far away, and Lewis holes for lifting them remain from Roman times. Here they are large and rough, some placed upright. This tower was built in four stages, with the top floor revamped in 1765, but inside the church is an arch made of Roman stones built into the tower, made in Anglian times and possibly reworked in the post-medieval era. It was later plastered over, but can now be seen again. Some decorated Roman stone remains there.

In the porch there is a stone that was once a Roman altar, cut through vertically, and redecorated around the Roman central figure and above his shoulders with Saxon interlace. As Hodges remarked, 'All sorts of idiotic theories have been put forth as to who this man is, and what he is doing.' We can safely say that it was reused as an Anglian memorial, possibly for a grave slab.

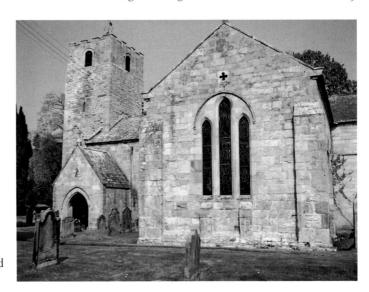

Warden tower, with Gothic and
later changes to the church.

One other survival of the period is a hammerhead cross that may be as early as the seventh
century, but this was brought in from an unknown site and erected in the churchyard much
later.

The rest of the church, which has no aisles and is cross-shaped, has thirteenth-century
features, and later additions can be clearly seen in the stonework. The transept arches are
modern, but rest on old pillars. The long transepts have lancet (pointed) windows, some
in pairs, and they are linked together by a string course, which flows over the hoods of the
arches. The chancel was rebuilt in 1889.

The church is used both for services and concerts, and efforts are being made to raise
money to reinforce the Saxon tower.

Corbridge: St Andrew

The village of Corbridge lies on a gravel terrace north above the River Tyne, where there
has been human settlement since prehistoric times. Particularly important is the Roman
settlement there, behind Hadrian's Wall – an early fort on the Stanegate frontier (Coria) that
developed into one of the main supply bases. After the abandonment of Britain by Rome,
the buildings would have slowly crumbled away, perhaps in part being used by squatters,
until the Anglian invaders began to settle along the river; choosing their site a little further to
the east, where the church now stands, to build their village and church, and using recycled
Roman stone in the same way that they did at Hexham. The church is described as 'the most
important Saxon monument in Northumberland, except for Hexham crypt' (Pevsner, 1992).

The church is monastic in origin. It has the next Anglian tower east along the river, built
above its west entrance, with the characteristic quoins that we have seen at Warden. The
earliest part was probably built before 786, when a bishop was consecrated at the monastery
there. Here, recycling was on a massive scale, for the builders removed a great arch, possibly a
gateway, from Coria and used it between the outer door and the nave. The large stone jambs

(sides of the door opening) have no vertical joints, and the surrounding stones are all Roman. The outer porch is more complex, with two semicircular arches, one above the other, and this end, now walled-in, presents a fine example of change and modification.

Again, the tower has no buttresses. The nave would have been 5.36 metres wide, long, with 8.8-metre-high walls. There is Saxon masonry in the nave walls, and two early window-heads. The chancel was narrower than the present one. Before the Conquest, the porch roof and gable were taken off and the side walls were continued upwards to form the tower, according to Hodges. The western gable of the nave is still there, for the east tower wall rests on it above the roof. After that there were many alterations from the eleventh to the thirteenth century, and the tower was changed again in 1729. The tower bears evidence of this great antiquity and some of the changes to which so many old churches were subjected. The tower is tall, thin and unbuttressed, clearly Saxon in the large stones of its lower courses. Its west face, seen from the road, splendidly illustrates what is old and what changes have taken place since its original entrance was blocked up. Opposite this doorway, inside, the massive moulded arch that faces east was lifted from the nearby Roman site and re-erected. With it came a considerable amount of smaller worked stone for the rest of the building, some of which can be seen in the walls of the nave above the arcade, where two round-headed Saxon windows have been cut through by later developments. The arches that replaced the Saxon nave are Early English, which is the predominant style of the church today. I will pursue this so that the picture of the church today becomes more complete.

Now we enter through a modern south porch that protects a splendid Norman doorway inserted into the south wall, with zigzag decoration and other designs cut into a masonry arch, which is supported by colonnades and capitals (crowned tops) with scallop designs.

The church continued to be used and changed. In the twelfth century the chancel arch was widened. This high, pointed arch particularly shows the change in style from the Saxon period. The south nave wall was pierced by an arcade, and an aisle was erected. An aisle was added to the chancel and the transepts were built, followed by an aisle to the north transept. The south aisle of the nave was widened.

Corbridge west, forming the west porch of the nave, later blocked in by changes to the lower Saxon tower.

The chancel at Corbridge south, basically thirteenth century, shows development through the Early English period, with the priest's door added later.

To the left as we enter, the solid Roman tower arch is impressive, but as we turn into a nave flanked by thirteenth-century arcades, the entry to the chancel is dominated by the much higher, sharply pointed chancel arch. There are clear signs that this arch involved a change of mind from those who built it, for the lower part was widened during construction.

Like other churches, Corbridge has been restored and rebuilt in parts, and the addition of high, rectangular windows adds to the light that is otherwise provided by lancet windows of varying heights, some single and some grouped in threes, as at the east end of the chancel. These lancets are splayed inwards to admit more light.

The present plan of the building shows how it developed according to the needs of the people and the fashions of the time, for Corbridge became an important medieval town. It had three other churches, now gone. The strong impression given on entering the building is of a profusion of pointed arches. There are two transepts and a northern chapel, with north and south aisles added to the original nave and an extended chancel, showing a need for more space. The north transept has a west aisle with a solid west wall; the pillars and capitals, although Early English, have sufficient variations for us to assume that building was a lengthy process. Some arches spring from walls and others from pillars.

We have seen from the outside that the west end has Saxon work in the tower, which extends northwards where the west wall of the Saxon nave lies. The south chancel outside wall is of a much later tradition with heavy but small buttresses topped with gables, and fine lancet windows.

There are other medieval features inside the church as fragments and fixtures, among which two carved heads on the wall of the south aisle fascinate visitors. The priest's door and low side window in the south chancel are inserts.

Bywell

There are two churches close together at Bywell, whose name means 'a spring on the river bend'.

Both are in the bend of the River Tyne on flat land and served a village that is no longer there. It is said that there was a village of twenty houses in 1825, including two vicarages and the White Horse Inn. St Peter's church is close to the river. In the mid-nineteenth century this village was moved to Stocksfield (a name meaning that it belonged to a religious foundation) to make way for a landscaping scheme now centred on Bywell Hall. There is a castle, but the interest of this section is in what remains of Anglo-Saxon architecture in both churches.

St Andrew's church is now redundant, but kept open. It has one of the most attractive towers in England, which was once probably the west entrance to the church. It is tall, without buttresses, and its quoins are alternated large and small sandstone blocks. Below and above the belfry are string courses – lines of horizontal stones that divide the tower into storeys. The windows are particularly attractive. The base of the tower may be older than the rest, which dates from around AD 1000, just before the Conquest. The nave was without aisles, with some old stone still in the walls. There is a piece of a Saxon cross housed now in the chancel.

Interest in the church's architecture does not stop there, but nineteenth-century restoration work was not good. The nave walls still have Saxon stone and there is thirteenth-century work in the south transept and lower chancel walls. The nave has no aisles and the chancel is quite a long one. The church contains some very fine medieval grave slabs and part of a Saxon cross.

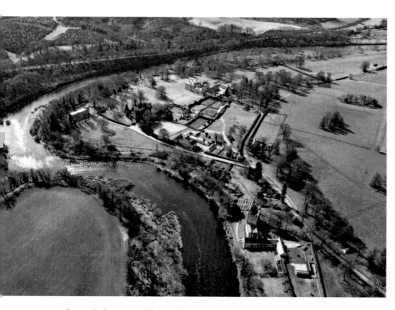 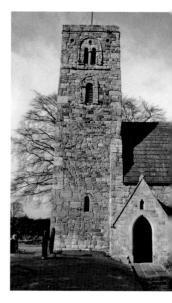

Above left: Bywell churches: one on the promontory of the river bend at the top left, and the other further along the road from that church to St Andrew's at the road junction, right. (Tony Iley)

Above right: St Andrew's Anglo-Saxon tower, Bywell.

St Peter's Church

This is a large Saxon church, of which the north wall of the nave and parts of the chancel walls are the only survivors. Four high windows in the north wall with large blocks supporting them have round-headed arches, and the nave has massive 'side-alternate' quoins. Presumably the nave was much longer in Saxon times. The north wall of the chancel has a blocked doorway with a square head, so there is much here to indicate a major Saxon church, with parts if its east end perhaps still projecting underground. It is quite possible that a bishop, Egbert, was consecrated here in 802, which gives an early date for the building.

The church developed, and the medieval remains are more evident than at St Andrew's church. Even so, nineteenth-century rebuilding was over-enthusiastic. The chancel with its lancet windows was remodelled in the thirteenth century. In the fourteenth century the squat tower was built, incorporating some Saxon work. The chancel arch was probably modelled on the original thirteenth-century arch. The nave north chapel was built in the mid-fourteenth century, with reticulated tracery under square heads. It seems that outside the north chapel a further extension of the building was to be built, as there are springers for three arches that were not finished.

Ovingham: St Mary

The church at 'Offa's people's settlement' is another with a tall, unbuttressed tower, this time of five storeys, clearly visible from the Newcastle–Carlisle railway. It is late Saxon, its date similar to that at Bywell, but it is not so elaborate, although its bell openings are identical. Whether it originally had a west door is not known. It did not have an arch into the nave. The only other Saxon features are the south-west quoins of the nave, as subsequent building has changed so much. The further development of Ovingham is outlined further on, as it is predominantly thirteenth century.

Heddon-on-the-Wall: St Andrew

The high place selected for the building of this church, as its name implies, gives it wide views over the surrounding land. The Roman wall lies very close by, and has been preserved along with the ditch in front of it and Vallum behind it. It may be speculated that its site was so commanding that the Romans could have made use of it. Evidence of a substantial Saxon church lies in the quoins at the south-east corner of the nave, where they are massive and laid on edge. Inside the church, on the chancel window sill, is an Anglo-Saxon wheel-headed cross.

The subsequent changes to this church began with a squared-off chancel in the twelfth century, and today we see that the sanctuary arch has big Norman zigzags facing west, and two parallel roll mouldings on the ribs that meet at a large keystone. The north capital has nail-head decoration. Next, the north aisle was built around 1200: the round pillars support capitals and pointed arches form three bays. Then the chancel was remodelled in the thirteenth century and an aisle was added to the south. The chancel has two pairs of thin lancets with

St Peter's church, Bywell: rounded Saxon windows high on the east nave face, and later developments of a chapel that remained unfinished.

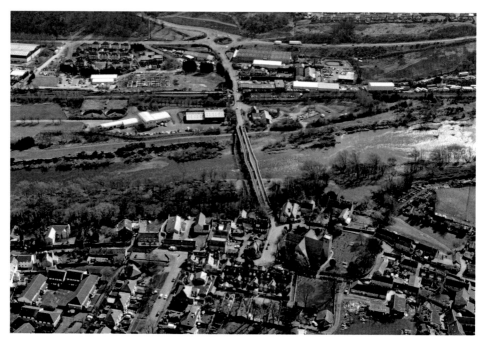

Ovingham, in line with the bridge over the Tyne to the right from Prudhoe. (Tony Iley)

a pierced circle above, including a stone head. The aisle pillars are rounded. In the thirteenth century the south door was inserted, but the porch is later, probably added in the fifteenth century. As with most churches, there was restoration in the nineteenth century.

Halton

The church is also situated in the Roman wall corridor, and its stones, along with those of other buildings around it, are largely taken from the fort of Hunnum that leads up to it. There is even a Roman altar stone from the fort, erected in the graveyard in the nineteenth century. The Saxon survival is not very obvious, as the mere use of Roman stone does not imply this, but outside on the north-west corner of the nave there are quoins that could well be Saxon.

The church is basically Norman, as we see in the chancel arch, but other changes were made from the sixteenth century onwards.

This brief examination of the Tyne Valley Anglo-Saxon work will now be followed by further examples throughout the county, beginning with Whittingham, where the tower and its quoins are some of the finest examples of early construction.

Whittingham: St Bartholomew

A settlement named after the descendants of Hwita, the church here has a superb Saxon tower base. Until the mid-nineteenth century, when the local vicar appallingly had the top part destroyed and rebuilt to his taste, this was an excellent example of a complete tower, unbuttressed and bound in by alternate long and short quoins. Normally this is a southern phenomenon. This method of constructing walls continued from the tower into the nave. The tower arch is like that at Corbridge.

The church and village lie in a fertile 'vale' between sandstone scarps to the south and the volcanic Cheviot Hills to the north. It has always been an important communication centre; a Roman road running from west to east lies buried under the fields there, heading for the A68, which now largely follows the course of a major Roman road from Corbridge and beyond to Scotland. Such roads would have continued to be used in Anglian times, though their surfaces would have been neglected. The richness of arable land and extensive forests would have attracted a settlement that would support such a fine church.

St Bartholomew's church has served, and continues to serve, a large agricultural area on the fringe of the Cheviot Hills, with the Vale of Whittingham to the south being of particular value for its arable land and its position as a routeway. The name of the settlement of Hwita's people in Anglian times was recorded in 1040.

The church stands above the road that leads to it, surrounded by a large graveyard. We know that the church was given to the Augustinians of Carlisle by Henry I, and at this time Norman work began. The remaining part of this new church is part of the north aisle arcade and a chancel built in the twelfth century, but which was rebuilt in 1725 and in 1871.

A narrow south aisle was added in the thirteenth century. The responds (half-columns bonded into the wall, supporting one end of the arch) of the chancel arch are of the same period. The north aisle was also widened then and a projecting chapel added to the east end of the south aisle.

Above left: Whittingham: the original Saxon tower before the demolition of the top.

Above right: Whittingham: inside the tower today, the tower opening into the nave.

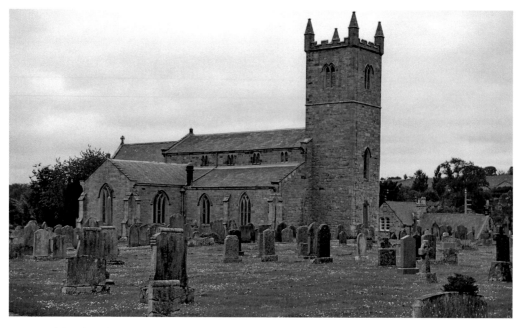

A view of the church from the north-west.

The tower went through changes when its arch was closed with a wall and a doorway cut into it. Two thirteenth-century tomb slabs were used in its construction – another case of recycling. Originally the south porch was thirteenth century, but it was rebuilt.

Bolam: St Andrew

The church appears isolated, as it is the focus of a settlement that has disappeared – like many such Northumberland villages – leaving strong ridges and furrows that were once ploughed to grow arable crops. Now covered with grass, these field systems show up extensively from the air and ground. The name, which is Old English, means that it was a place of tree trunks or a rounded hill, probably a clearing in the woodland. The building stands on land that falls away sharply to the north of the surrounding wall, giving an extensive view of land as far as the Simonside Hills on the horizon. The wall defines an extensive graveyard that contains stones from the late seventeenth century. To the west are the old rectory and the site of the abandoned settlement that lay between the church and Bolam Hall.

The church has a fine late Saxon western tower, rising high, unbuttressed, very much like those at Bywell and Ovingham. The characteristic quoins, some massive, define its period. Its coursed sandstones run between them, and high windows are paired by the insertion of a rounded pillar that is set back from the opening. These windows are set in each face of the tower at the same level. A close look at the north external wall reveals more large sandstone blocks that may be some remains of the Saxon nave. Like all other early churches, it has been subjected to modification, rebuilding according to the period and decay. It has emerged from all that time could do to it as a very attractive and interesting building, with many preserved signs of these historical changes.

From the outside it stretches extensively from west to east, with varying roof levels above its different parts. Inside, entering through the Norman doorway, we see that the tower arch is tall, narrow and rounded at the top. It now contains the font. The pillars and capitals that support this arch are decorated in Norman style, and are later than the tower. The nave, running east from this, is long, proceeding to the chancel through a complete Norman arch and the remains of another that has been removed to extend the chancel. The one aisle to the south has late twelfth-century arches, the eastern bay having a chapel. The chancel is thirteenth century, and the south wall a century older; the rest was a matter of keeping the fabric in good order. Raw stone has been left or exposed in all its beauty. Windows have been replaced or added to show the interior in a good light. When the church was extended in the thirteenth century the responds off the former sanctuary arch were left. Voussoirs (wedge-shaped stones forming the arch) with saltire (diagonal cross) decoration were also left.

The influence and wealth of local landowners and others of social importance ensured that the upkeep was maintained. We see their rewards in the memorials to them in the church, such as medieval grave slabs or the recumbent statue of a knight in armour displayed in the south chapel. In the same chapel there is a small memorial window marking the place where, in the Second World War, a German bomber pilot, pursued by fighters, jettisoned his bombs, one of which crashed through the south wall but did not explode. The others

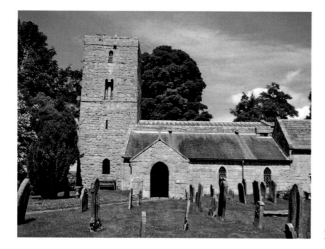

Bolam from the south.

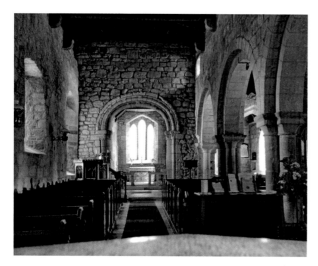

Bolam: the chancel from the west.

Bolham: south doorway.

exploded to the north outside the wall. The pilot visited the church much later and, in an act of reconciliation, was forgiven. We know the facts of this episode, but there must be many other features in the church that have untold stories.

We have to look in detail at the features that tell the story of architectural change and development, all emphasising again that details help us to trace changes. Absences for some periods are due to the Anglo-Scottish wars and other border conflicts, even though there must have been some periods of peace when people could continue to live their lives as farmers and herdsmen, in between the crop failures and disease that added to losses in war. Outside that there was plenty of arable land, pasture and woodland for them to earn a living scattered over a wide area, and the church would bring these people together occasionally, but we cannot put faces to them. We know little of the people who were not notable in any way, yet they loved, had children, are perhaps buried in unmarked graves around their church, and are the great element of continuity to this day. Their homes were a huge contrast to the solidity and beauty of their church; when they entered this it was like entering another world, yet familiar to them if they attended services.

Holy Island: St Mary

The parish church predates the Norman priory there. Although documentary evidence places the island at the centre of Anglo-Saxon evangelism based on its monastery, apart from some sculpted fragments, the remains of this vital core seem to have been built over.

We know what an immensely important place Holy Island was, particularly for the extraordinary achievement of the Lindisfarne Gospels. So much written about it is still available; take the words of Aldred, for example, who added an Anglo-Saxon translation to the Latin text:

> Eadfrith, Bishop of the Lindisfarne church, originally wrote this book, for God and Saint Cuthbert and – jointly – for all the saints whose relics are in the island. And Ethelwald, Bishop of the Lindisfarne islanders, impressed it on the outside and covered it – as he well knew how to do. And Billfrith, the anchorite, forged the ornaments, which are on it on the outside and adorned it with gold and with gems and also with gilded-over silver – pure metal. And Aldred, unworthy and most miserable priest, glossed it in English between the lines with the help of God and Saint Cuthbert…

The island had bishops who became saints; it had crafts that were outstanding, carried out in a community that has left no buildings behind. It was destroyed by Viking raiders but venerated ever after. However, whatever we may conjecture about this community and how it lived, we have no large survivals. It has a written history, the Gospels and tombstones, but little more material on the ground to show for it.

The priory that was dissolved by Henry VIII may have covered something earlier, but we don't know. The parish church, surviving the Dissolution because it was the parish church, has some features that hint that it is older than the priory; there are early quoins at the east end of the nave, a narrow chancel arch that was replaced by another in the thirteenth century but still rises above it, and above that a narrow Saxon doorway with large blocks

St Mary's, Holy Island west; the parish church still in use.

of sandstone as its jambs, suggesting a great height of the roof. The wall with the arch also looks to be much older than the inserted arch. The church lies to the west of the priory on the same alignment as the priory church.

For the rest, the remains in stone are a few fragments that are nevertheless important indications of early activity on the island.

Woodhorn: St Mary

The church looks modern from the outside, but inside there is a progression from Anglo-Saxon times. The nave is of that period, as are its high rounded windows; Norman arcade arches cut through them. A window on the south side of the nave has a unique pattern of concentric circles.

Two bays on each west arcade are twelfth century, but the north arcade has thicker columns to support them than the south, which are later. There is nail-head decoration around the bases (Early English). The arcades branch out into transept arches, with mid-thirteenth-century decoration. The chancel arch is thirteenth century, but the chancel was rebuilt in the nineteenth century, and during rebuilding revealed an apse beneath the floor, presumably pre-Conquest. The base of the tower suggests a Norman or earlier date, but there is little left of it. Pieces of stone sculpture have survived.

Whalton: St Mary Magdalene

This church has an eleventh-century tower; the round tower arch is Saxon. The other features of this church will be described later.

Sometimes the location of a church may suggest an early foundation, such as that at Newbiggin on the coast, a place favoured by early monks, but St Bartholomew's church has nothing more than a suggestion that its tower, remodelled in the thirteenth century, may have been much older. That is speculation, but remains a possibility.

Some small inland churches like those at Chillingham and Old Bewick have very large blocks of stone as their foundations, but again there is no proof that they are Anglo-Saxon.

Hartburn: St Andrew, which will be examined in more detail later, has large Saxon quoins on the east, and the core of this church would have been of that date. Recent excavations for improvements for a new heating system have revealed building to the west of the tower that may even be Roman, but further excavation has not been possible.

Warkworth: St Laurence

This also has evidence of an earlier Saxon church, buried at the east end, but this is no longer visible. It is highly likely that many churches have similar buried structures that have yet to be revealed, so that any changes and improvements must always include an archaeological 'watching brief' to ensure that nothing is missed. Marc Johnston, who had such a brief, found 'two phases of a pre-Conquest church under the external wall of the north nave' (pers. comm.). In 727 Coelwulf granted the church and land to the Abbot of Lindisfarne.

Anglo-Saxon Sculpture

We have seen that there are many fragments of Anglo-Saxon sculpture in churches that have fixed examples of early work, but there are portable examples that are important too. Outstanding among them is a cross at Rothbury. Parts of this are illustrated here; it is possibly the earliest stone 'rood' (cross) in the country, and of great beauty. Part of it forms the base of the font in the church today, and other fragments are in the Great North Museum.

Crosses form a large part of Anglo-Saxon survivals, with common themes such as the crucifixion, interlace and vines as powerful images. The vine leaves and grapes symbolise the blood of Christ and the words of the Gospel: 'I am the vine and you are the branches.'

The remaining fragments from Hexham Abbey, many displayed inside the building but others in store at Durham Cathedral, give some idea of what the building would have contained, with a particularly important 'rosette' stone linked to French Saxon churches being on display in a niche in the nave wall.

At Holy Island there are grave markers from the seventh to the late ninth century, all of great importance, especially as there is little else remaining there of this period in the North's history.

Norham church has some fragments that were badly patched together and displayed in the church.

This page: The Rothbury cross.

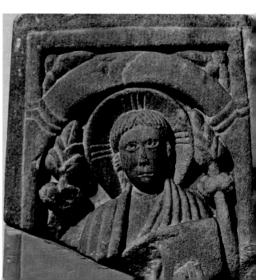

2

THE NORMAN PERIOD AND TRANSITIONAL ARCHITECTURE

Although Anglo-Saxons and Normans came from the same north European homelands (Normans actually being Norse, or Vikings) their development led them in different directions until one branch defeated the other at Hastings in 1066. By that time the Normans had built up a powerful state with the twin pillars of Church and Castle as their strength, with bishops having the power of princes. Although their churches had some things in common with Saxon ones, Norman architecture had become more sophisticated and elaborate, well-tested and tried, and ready to be part of the Conquest.

Norman churches are often known as 'Romanesque', a term derived from the rediscovery of Roman building techniques, particularly in constructing arches and vaults. The Normans had already assimilated these and put them into practice before the invasion, and applied them to English churches, monastery building and rebuilding.

All over Britain, similar features in buildings can be seen, but behind this conformity was a ruthless imposition that particularly cost Northumbria dear when the land was ravaged and burnt to such an extent that there was nothing to record in the Domesday Book. With the new rulers and churchmen came new monasteries, which often took either the best land for their income or, through skill and organisation, made the best of poorer land.

Norman architectural survivals vary in Northumberland's buildings, from those on a grand scale in Brinkburn priory, for example, to small parish churches. These survivals are characterised by the development of the rounded arch, which carries the weight of the superstructure down to a series of pillars from which the arches spring via capitals like cushions at the top of the pillars. The same rounded arch is used as an entrance to the church, often elaborately carved, and as a chancel arch – although there are some churches where the chancel arch is so plain that it has been mistaken for the more austere Anglo-Saxon. Another feature was the division of outside walls into bays by broad, flat buttresses.

The styles of decoration are given names such as chevrons, billets (half-cylindrical or rectangular blocks at regular intervals), cables (like twisted rope) and nail-heads (like repeated pyramids). Brinkburn has beakheads (rows of bird or beast heads). In some large buildings, like Holy Island priory, the pillars are decorated, in this case with chevrons like those in Durham Cathedral.

There is a Transitional period between Norman and Early English when the new pointed (Gothic) arch and the Romanesque rounded arch exist in the same building and their styles overlap. Hexham priory is a good example of this, and so is Brinkburn priory, as we shall see.

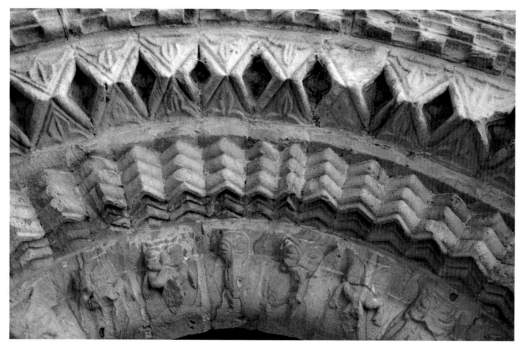

Brinkburn: the Norman doorway, including beakhead decoration.

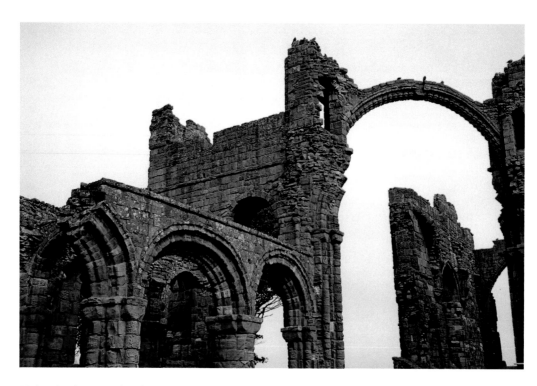

Holy Island priory church's ruined east end.

There now follows pictorial evidence of the Norman period, beginning with the church at Warkworth, which, although there is a proved Saxon building beneath it, is essentially Norman with later additions.

Warkworth: St Laurence

The village of Warkworth is a superb example of a medieval planned settlement that lies in a loop of the River Coquet as it nears the sea. The south side is cut off by the artificial ditch of a Norman motte-and-bailey castle, which was owned by a most influential northern family. The church stands on the riverbank close to the medieval bridge at a lower level from the castle, with the village built in an orderly way between them.

The name Warkworth is from that of a woman, Werce, who had a settlement in a clearing in Anglian times, and there is a reference to an early church there built by Coelwulf, a Northumbrian Anglian king, who entered Lindisfarne monastery and gave it to the monks there. The church now occupies the site that was reported to be the stone church of St Cuthbert. It is one of the finest and largest Norman church buildings in the county, but excavations during the 1870 restoration located the remains of the foundation of an eastern terminal immediately west of the chancel arch, with 4-foot-thick walls, 2 feet below the present floor level. There is also a pre-Conquest headstone and other stones from this period.

What we see today was started between 1110 and 1120 on a grand scale in the reign of Henry I, on land given by him together with a large income for it. This building has a long aisle-less nave leading to a chancel that has a groined roof. There is a rare circular staircase in the north-east angle of the nave, its internal door now blocked by the pulpit. The next phase of building was the western tower, its entrance breaking through the Norman west wall and the south aisle.

Although the approach to the church is from the south, we begin by looking at the north wall to appreciate the Norman building. It has had to be reinforced with buttresses because of its tendency to lean towards the river, with the original ones still in place, broad and flat. There are five plain, rounded windows and a blocked door of a less elaborate but similar style to the one at Brinkburn. A string course runs horizontally at the foot of their sills and another links the window arches. Massive buttresses had to be added to support the north wall. At the east end of the wall a shallow projection marks the housing of the newel staircase mentioned above. The chancel has small rounded windows and a narrow door, and again the string courses and buttresses are prominent features.

The 1200 tower was sturdy and did not need buttresses. At the south-west angle there is a newel staircase. Its final stage, the belfry, and its broached spire were built in the mid-fourteenth century. A vestry was built after the lower tower, on the north wall, in the thirteenth century, and this formerly had two storeys.

Finally the south aisle was added in the late fifteenth century. The main view that greets the visitor today approaching from the south is of the two-storey porch and the south nave wall, its clerestory destroyed in a nineteenth-century restoration by Dobson, who also renewed the windows. Sadly the restoration also replaced the fifteenth-century east-end windows in the chancel with Norman-type ones.

The church is entered through the rib-vaulted porch, where the south aisle to the right is an arcade of five bays with slender shafts and quatrefoil piers, lit by large windows. The central aisle leads to a remarkable chancel that in its vaulted roof resembles Durham, and is likely to date from around 1130.

This is one of Warkworth's finest features, with its zigzag decoration. The chancel arch has rectangular responds, scalloped capitals and the arch has a striking decoration. As we approach it, we may remember that under our feet is an earlier church. In modern times it has been the backdrop of many performances, including the local drama group's *Murder in the Cathedral* and concerts by the Alnwick College of Education choir before the college closed in 1977. Its architecture is so attractive that the church should be used as much as possible in addition to its services.

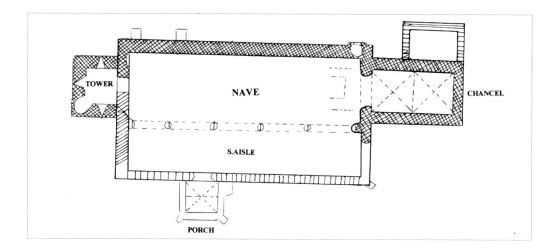

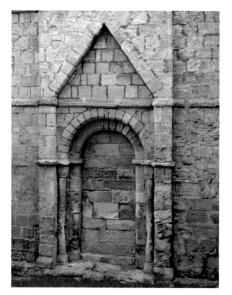

Above: Warkworth church plan. The cross-hatching is Norman.

Left: Warkworth north wall, with a doorway less elaborate than that at Brinkburn, but similar.

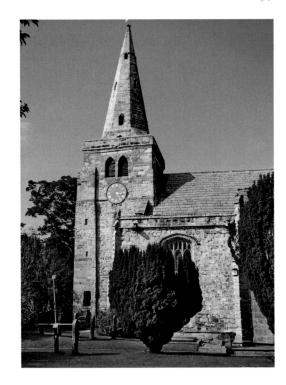

Right: Warkworth tower from the south.

Below: The Norman arched chancel ceiling.

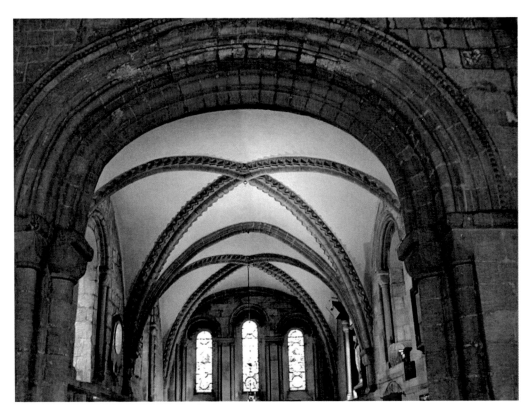

Norham: St Cuthbert

The Anglian name of Norham is *Ubbanford*, the most recent one meaning the northern settlement. An earlier church was started or rebuilt there by Eogred, a Bishop of Lindisfarne (830–45). However, nothing remains of this earlier building in the present fabric, although there are some sculptural fragments of crosses.

On the banks of the Tweed, St Cuthbert's church lies to the west of a formidable castle that was built by Bishop Ranulf Flambard within the County Palatine of Durham. Like Warkworth, it is a parish church, and shows the strong influence of the masons who built Durham Cathedral. Much of the church is modern, but the south arcade and chancel are Norman (*c.* 1170). A striking feature is a row of large, rounded piers, richly decorated capitals and arches springing from them. Of these five bays survive. The chancel arch dates from around 1170 too.

Outside, the highly placed Norman windows survive well. On the south side there are five, with a string course on which the sills rest, and flat buttresses separate the windows. Between the ground and that, another string course loops over a priest's door, which has a plain arch that contrasts with the elaborately-decorated window arches. To the east, the chancel could have ended with an apse but it now has a flat end from when it was demolished and rebuilt in the fourteenth century. Above the windows is a corbel table that supported the roof. A corbel is a projection that was meant to support something. A corbel table places a number of these corbel supports in a line and can be ornamental rather than functional.

Ancroft: St Anne

St Anne's church is quite spectacular from the outside. Approached from the south up a road that bends sharply around a 'deserted' village, a massive tower appears from which the south wall of the building stretches out to display a Norman arch that had been abandoned as the main entrance and another built to give access to the later tower. Above it, running east is a corbel table that is twelfth century and a buttress of the same period that was the south-east corner of the nave.

The Norman doorway was blocked when a tower was added in the thirteenth century of a size and thickness that appears to be defensive (like that at Edlingham), a refuge for the clergy and people perhaps. There are no signs of an earlier tower.

The church was restored in 1836 and 1870, extending the nave further east, and any changes were designed to respect the original building.

Ponteland: St Mary

At the centre of large estates, some of which serve as commuter belts for Newcastle, St Mary's church lies in a much older centre. Opposite the church is the Blackbird Inn, incorporating part of an early fortified house, possibly of the thirteenth or fourteenth century. The name Ponteland (Eland in 1242) means either 'an island in marsh' or 'cultivated land' by the River Pont.

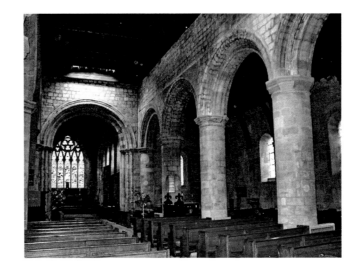

Norham: internal pillars and arches of the south nave, owing much to Durham Cathedral.

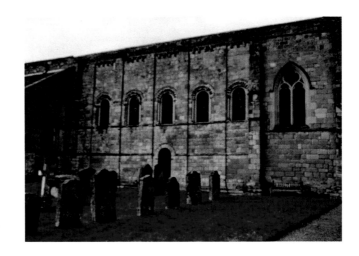

Norham: the south chancel wall, a good survival of Norman workmanship.

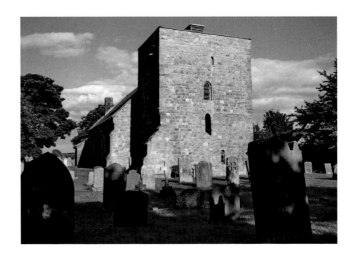

Ancroft from the west. The tower looks defensive.

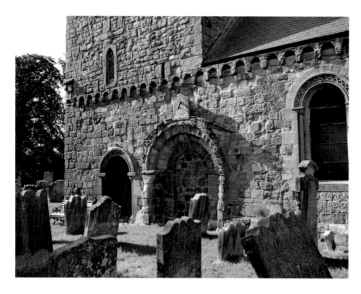

Ancroft: a good embellished doorway, replaced but retained when the tower was built.

The church tower and its arch are Norman, mid-twelfth century, with walls that are 4 feet thick. The doorway is beneath a lintel that is made of two large blocks of stone, above which is a blank tympanum (stretched between the lintel and the arch above it). The tympanum arch has twelve stones (voussoirs) decorated with chevrons/zigzags. Below that is an arch made up of sixteen stones with chevrons. The jambs are stone cylinders with their capstones built into the walls, weathered, but the southern capital shows traces of Norman scallop pattern.

The tower's first two stages are Norman, with a round-headed window of this period in the north wall. The east window splays wider into the inside, and the west wall has another original window. Inside, the arch that leads into the nave is sharply pointed and belongs to the thirteenth century. It has no capitals and springs directly from pillars on either side. There are not many other traces of the early Norman period, as the church was entirely rebuilt and the aisles added. What remains are the responds of the tower arch, so that it seems that the church had a Norman north aisle.

In the thirteenth century the chancel and north transept were built, the latter still in its original condition, with three lancets in the north wall and two in the east. The chancel also had pointed windows; it was altered in the fourteenth century, but all its buttresses survive. So do two of its windows, but the rest are replacements from around 1320. To the east, the lower parts of the buttresses survive.

The chancel arch is very broad, and ends with human heads as corbels, which represent Adam and Eve, re-cut. Between them is the serpent. The east-facing arch has the remains of an old roof line to the north. A piscina (basin for washing communion vessels) in a transept to the north has dog-tooth decoration typical of the thirteenth century.

Around the 1350s the east, south and north windows were enlarged, and they have Decorated-style tracery (intersecting ribs in the upper part of the window springing from slender shafts). The south aisle was modified around 1400, where the windows are of the Perpendicular style (with upright tracery), although the south transept is built mainly of

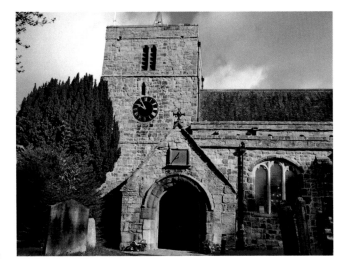

Ponteland: south porch and tower.

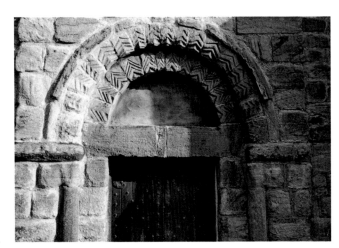

Ponteland west: Norman doorway.

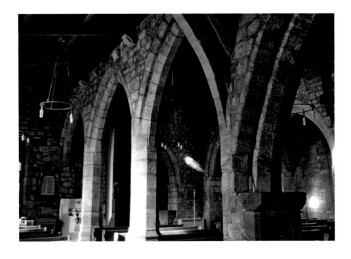

Ponteland: south aisle arcade.

Norman stone. The piers of the south aisle are octagonal, and arches, built of two chamfers (angled), link with the piers without having capitals. Outside, the south transept does not have buttresses, as it was rebuilt entirely in the fourteenth century.

The north aisle was rebuilt in the fifteenth century, but the doorway in the west bay is earlier. The arcade was rebuilt again in 1810, using old masonry. The west wall, heavily restored, has no windows.

Two of the most attractive small churches in the county are at Old Bewick and Chillingham, the former hidden away in a small stream valley and the other lying close to the protection of a castle. Both have suspiciously large sandstone blocks in their foundations, which are often found in the Anglo-Saxon period, and both have Norman features.

Old Bewick: Holy Trinity

The church lies in a secluded valley at the foot of a sandstone scarp that is rich in prehistoric remains. The course of the Kirk Burn opens out to a wide, beautiful view of the range of the Cheviot Hills, but the east faces the scarp. We know that it belonged to Tynemouth priory from around 1100. Although it became ruinous it was heavily and lovingly restored in the late nineteenth century, with many of its original features respected. Its name means that it was a farm renowned for its bees.

It is a church of great power and tranquillity, with emphasis on large, thick, raw stone inside and out until the altar is reached. It has no aisles, and the chancel ends with a rare apse. No one spoiled the effect by covering it with whitewashed rendering, and as we approach from the west we are faced with two chancel arches of the same Norman period, with the apse curving out from the second. Decoration in the form of saltire crosses, cable moulding and possible woodwose heads (with teeth like piano keys) attest to the importance of this building to its users. Surprisingly, the modern terracotta painting and stars with the 'Holy, Holy, Holy' lettering above the altar and faint light coming from small narrow Norman windows considerably enhance the effect. Outside, the apse is still visible, heavily buttressed and with an inserted window that replaced the Norman one in historic times.

This is truly a special place that has attracted many people for years, yet from a casual glimpse it looks from the outside like a village school with its little bell tower. In the churchyard is a massive slab of sandstone that spans the burn and gives access to the scarp. The graveyard too is full of interest.

Chillingham: St Peter

Chillingham's name stems from the fact that it was a settlement of people named after Ceofel. The church stands on a platform from which the land slopes steeply to the west (*see illustration on p. 45*). As at Bewick, the massive base sandstones suggest an earlier construction, and the exterior shows signs of many phases of rebuilding, such as altered roof levels, a blocked doorway on the north side, and sheets of modern glass at the east, which allow the congregation to see the trees and sky. It has a 'traditional' graveyard, where the monuments of different periods are scattered.

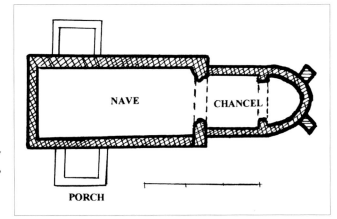

Plan of Old Bewick; the old church was rebuilt in the nineteenth century on its original Norman foundations, with its apsidal east end clear, supported by large buttresses (scale bar: 30 feet/9.14 metres).

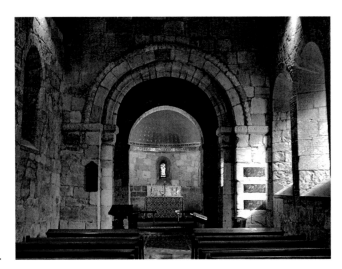

Old Bewick: interior from nave to chancel through two Norman arches.

Old Bewick: north-east end, where the buttress meets the apse.

The narrow, aisle-less nave is entered through a Norman south doorway; the church has been heavily restored, though the chancel is originally twelfth or thirteenth century, with some fragments of saltire crosses, as at Old Bewick, built into the walls. The most dramatic addition is the 1443 memorial tomb to Sir Ralph Gray and his wife – an incredible surprise in a small country church, until one remembers the castle nearby.

So far I have looked at many parish churches, but now turn to three large monastic foundations that show Norman work, beginning with Holy Island priory, within the same County Palatine as Norham.

Holy Island Priory

Holy Island priory was built at the end of the eleventh century, at about the same time as Durham Cathedral, as a cell of the Benedictine monastery by the Bishop of Durham. We have no definite idea what was on the site before then, but the scale of the church of the monastery and its striking red sandstone might cover something earlier. It is part of the island where the village is built, with a dolerite ridge rising to the south, cutting off the view of the sea, and lies close to the curved harbour.

The photographs show that the Durham connection is obvious; there are so many similar features including the decorated pillars of the north aisle. The piers are alternate circular and compound cluster constructions, closely spaced, the circular ones having zigzag, lozenge and fluting patterns. Arches spring from block capitals on the top of the pillars, and above this arcade was a gallery and a clerestory.

The west entrance is an elaborately zigzagged arch (heavily restored) flanked by walls with blank arches and turrets. The nave ended with an apse in Norman times, but like Norham it was later squared off when fashions changed; the apse here can still be seen at a lower ground level. There were two aisles of six bays and two short transepts. Both chancel and transepts had rib-vaults resting on block capitals. There was a tower at the crossing that grew from four clusters of three shafts, a decorated arch of which rises dramatically into space. The red sandstone chosen has weathered in such a way that it is an equally remarkable feature, giving the building a marvellous new life in its decay. Other features to survive are corbels resting on carved stone human heads.

The external north wall is divided into bays by flat buttresses of the type we have already seen at Warkworth and Norham; the south wall has almost gone. A string course runs under the window sills, and a second runs over their arches. The transept east walls are rounded/apsidal.

The rest of the monastic buildings date from the thirteenth century; they will not be included here, but they lie to the south of the church and are distinguished by the choice of duller sandstone.

Brinkburn Priory

On a site named either as the brink of the water or after Brinca's descendants, the priory church is delightfully situated in the River Coquet valley within a bend. Overlooking the site chosen for its building is a pre-Roman enclosure on a promontory, by which the car park is placed.

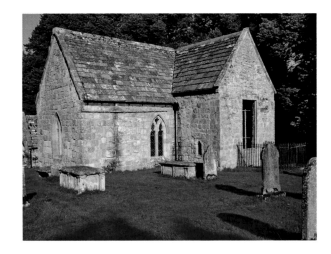

Chillingham from the south-east.

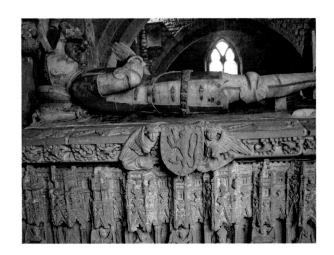

Sir Ralph and Lady Gray's tomb.

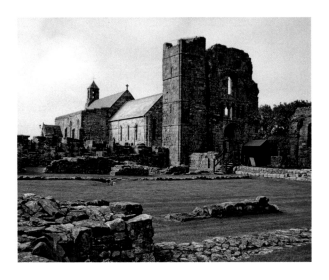

Holy Island priory and present parish church from the south-east.

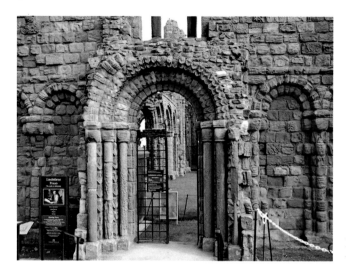

Holy Island priory: the restored
west entrance.

After the Dissolution of the Monasteries, the Augustinian priory was taken over by a local family; much of the church survived and was eventually restored, the monastic buildings to the south being converted into a house for the Fenwicks. This has been restored by English Heritage, with some of the original features still visible. There are some fine examples of Norman workmanship in the church, but it also notably offers the changeover from Norman to Gothic/Early English, both styles appearing together in a Transitional style. Thus rounded Norman windows appear actually higher than the newer pointed style.

There was not much land on which to build the priory on the 'haugh' beside the river, but the thin strip included a water mill. It is a peaceful and beautiful place, isolated and well-suited to a contemplative life. There would have been plenty of fish, as the river is famous for its trout and salmon. The partial destruction of the buildings has given it romantic and dramatic appearance, and the acoustic qualities of the roofed church have attracted high-status concerts and recordings. Its cloister has been used for dramatic performances and concerts by the local middle school.

The photographs show the main features of the church, which was built in 1190–1220, at the same time as most of Hexham priory. The nave has six bays and an aisle on its north side. The doorways into it are Norman, the most elaborate being the north door, which led out to the secular world.

The late Norman ornament includes beakheads, chevrons zigzags, and billet with a triangular construction above it containing three Gothic arches that are trefoiled (having three lobes) on thin pillars, contained in two string courses and linked by running arches. It is similar to that at Warkworth, but far more elaborate. The two doorways to the south lead from the nave to the cloister, part of a processional route, with a blind arcade of trefoiled arches between them and five rounded windows above.

Inside, the fact that there is little furniture makes it look large, and its austerity and the light coming through the widows give it a quality that few buildings have.

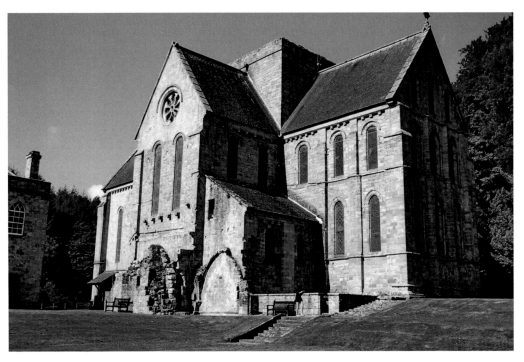

Brinkburn: a general view from the south-east, with Norman arches above Early English.

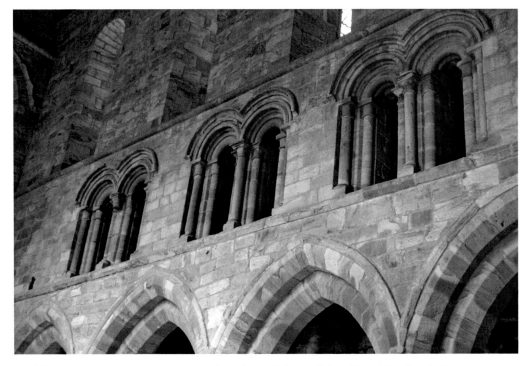

Brinkburn: north nave aisle. Norman arches above Early English; a Transitional period.

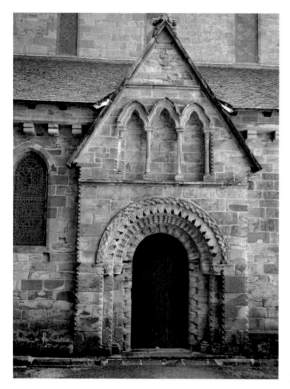

Left: Brinkburn: north entrance with beakhead and other Norman decoration.

Below: Hexham, showing the church in its position within the town.

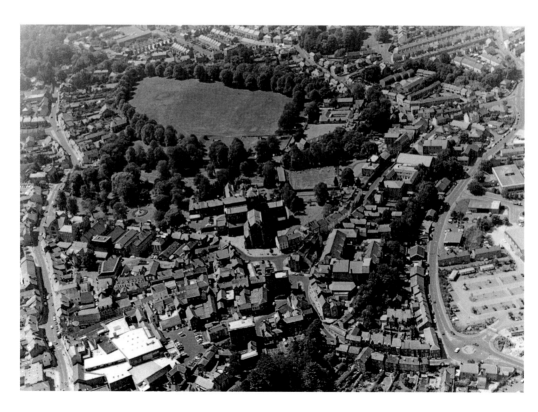

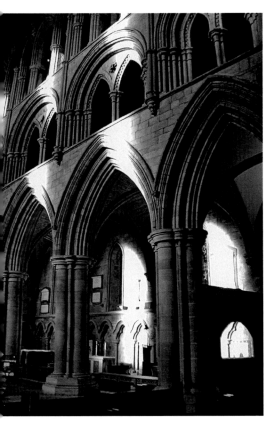 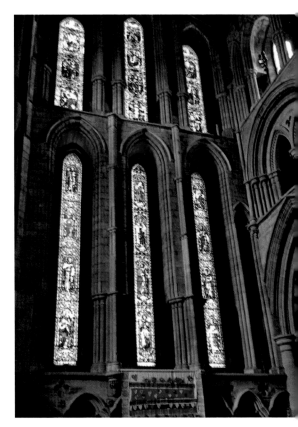

Above left: Hexham east arches of the north transept.

Above right: Hexham north transept, thirteenth-century windows, tall and slender.

The Priory Church of St Andrew at Hexham

This parish church is also a classic example of the Transitional period between Norman and Early English, built at about the same time as Brinkburn, again by the Augustinian order. We have seen how the site was used for the building of Wilfrid's great church, monastery and cathedral. Little of this remains, because after a long period of neglect following Viking raids a rebuilding programme was begun in 1113. The nave was built with an aisle only on the north, but this did not survive, so we are now looking only at transepts and chancel, the oldest parts dating from 1180–1250. Much had been restored in the nineteenth century, but it is possible to piece together some of the earlier building.

From the outside the emphasis is on lancet windows, but from the inside of the chancel, bearing in mind that the far eastern part was demolished and rebuilt in the nineteenth century, the late twelfth century is to the fore. The chancel has six bays including the nineteenth-century one, with thick pillars, topped by capitals ornamented with leaf pattern on the south side (plain on the north) supporting ornate arches. There are north and south aisles with graceful ribs and leaf-decorated bosses.

Above this, the triforium arches have two windows in each bay. To the south-west there is dog-tooth ornament and to the north it is in all the bays, so that the south triforium was probably built first.

The clerestory has three-part (tripartite) arcading and a wall passage.

The crossing is the meeting place of the transepts. The south transept may have been built first, and its arrangement of arches is plainer at a low level. It has an vaulted, ribbed east aisle. The triforium again has Norman and Early English features, the rounded arches containing pairs of lancets and a quatrefoil, but no dog-tooth. The clerestory above it has window arches springing from many thin clusters of pillars. The north transept is one of the most beautiful examples of Early English tall lancet windows in the county, and may have been built later than the south transept. The north wall has arches that are more elaborate than those in the south transept, but the same pattern of pointed arches held in a rounded one applies too. It has a vaulted aisle with leaf-formed bosses. The nave arches of the crossing are pointed.

It is impossible to isolate purely 'Norman' features in Hexham Abbey that stand by themselves, but the interest lies in the way in which two traditions of architecture are combined so well over many years' building, time to change many details as fashions changed.

One great asset of Hexham Abbey is its medieval woodwork and paintings, mainly from the fifteenth century, which are rare survivals, as well as its sculptures.

Edlingham: St John the Baptist

The church lies in a shallow valley along with a castle and village at the foot of the Fell Sandstone scarp which marks a main route from Alnwick to Rothbury. Around it can be found some of the most pronounced rig and furrow ploughing in the county, now grass-covered. It is essentially a medieval landscape. The name appears as Eadwulfincham in 1040, a settlement named after Eadwulf. The churchyard is extensive and the enclosure rounded.

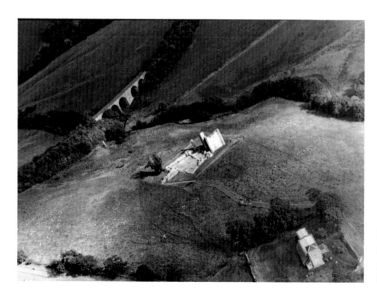

Edlingham church (bottom right), the castle and the railway viaduct (top left) from the west.

Edlingham west: through the chancel arch.

The earliest church is Norman, with a nave, chancel and south porch remaining. The south and east walls of the nave survive; they were built in the first half of the twelfth century. The doorway into the later west tower is a simple construction with a semicircular tympanum and a round-headed window that can only be seen inside the tower. The walls are very thick.

The south door, today's entrance through a porch, is a semicircular arch of two orders, standing on shafts (pillars) with block capitals. The arch above this has a hood moulding with billet ornament (like logs or blocks). A smaller seventeenth-century doorway is set into it.

The chancel arch, broad and simple, is another early Norman feature, although the chancel that it leads into is smaller and later than the original. The north aisle was added in the late twelfth century, forming a low arcade of four bays that have rounded pillars and moulded capitals to carry the arches. These capitals have vertical bands of nail-head decoration, and the nail-head is repeated on the pillar bases. The arches are of two orders, one of them chamfered.

The tower was added later and has all the appearances of being defensive, though the castle is close by. The windows are very small. At the north-east angle of the aisle the buttresses are built in a Perpendicular style, and the north wall is probably of the same date, around fourteenth century or later. The vestry was added in 1726. Restoration gave the east end of the chancel some obvious copies of the Norman style in 1864, but the 1902 restoration was more sensitively carried out.

There are other interesting features inside the church, including two medieval grave slabs used as a step from the porch, and a large gravestone of an important cleric found in the field by the castle. The church is well kept, used and attractive.

Felton: St Michael

In a way, Felton church is in a curious position *vis à vis* the village. The village grew up at a fording place over the River Coquet, acquiring a bridge and developing like a ribbon on the route to the north. Its name is an early Old English one, which connotes that its place then was among open fields. The church stands high above the river to the west, within its extensive 'traditional' graveyard, where the gravestones have not been swept to one side to help to make it easier to cut the grass.

As I lived in the village for eleven years and attended the church services, I have grown to know and like it, but even so there are many aspects of its development that are not easy to understand. The church was given around 1199 to God, St Peter and the canons of Brinkburn by William Bertram II.

At first it looks as though someone has taken the roofs away, as they are so low, though this does not apply to the chancel. The fourteenth-century porch is massive. An unusual bell-cote with a pyramidal roof was likely built in the sixteenth century, but its projected base has within it a truncated spiral stair of the twelfth or early thirteenth century. A walk around the outside is particularly spectacular when we reach the east end of the south aisle, where an intricate Geometrical window is carved out of a huge single sandstone block.

The church has a nave with two aisles and a chancel. Originally it was built without aisles as a long, narrow building; we can see the early work in the chancel arch, the south doorway and south wall of the chancel. The rib-vaulted porch seems to have been the first addition in the later thirteenth century.

The south arcade, which incorporates reused stone, is difficult to understand because, when we have entered through the massive porch and doorway we encounter another doorway,

Felton church stands at the end of a thin clearing in woodland, above the ribbon village.

Felton: the window of
1300, carved out of a solid
block of sandstone.

now part of the south arcade, which dates to around 1200 and must have been the entrance until it was turned into an arcade arch. This suggests that the nave was once aisle-less and its south wall, including the doorway, was then turned into an arcade for the south aisle, and a new south wall was built. The arches are thirteenth century, the same date as the chancel, and the chancel windows are restored lancets of the same period.

The chancel arch is of two chamfered orders, with semi-round responds with moulded bases on square and chamfered plinths. The capitals have square, hollow chamfered abaci (flat slabs on top of the capitals). The aisles were added in the fourteenth century.

The north arcade has five bays, the arches springing from moulded capitals on top of octagonal piers. The last medieval addition was a porch that enclosed the older one, around 1400; it is massively constructed, with a stone ceiling supported on chamfered arched ribs. So there has been much chopping and changing, but the earliest part of the church is twelfth century, and much of the rest is thirteenth or fourteenth century, with the superb window at the east end of the south aisle being inserted around 1330. It has five lights within it, with a central inner circle of an eight-petalled flower.

The north wall of the church was extended around 1845, partly rebuilt around 1900, and a vestry was added in 1870. The east end was rebuilt in 1884. The gravestones in the churchyard have been thoroughly recorded and printed by the local history society. This data is a valuable guide to the people who lived and died there.

Longhoughton: St Peter

This was a chapel before the Dissolution, subordinate to Lesbury. It was given to the canons of Alnwick Abbey between 1143 and 1152. It is believed by some that there was a pre-Conquest nave and chancel, but the outstanding feature is its massive, thick Norman tower, built before the end of the eleventh century. The mouldings of this tower arch are very rich. The west and south tower windows are original in the lower part and the stone is reddish in colour

– different from the lighter grey of the upper part. Before this tower the nave and chancel were probably earlier, mid-eleventh century; the chancel arch belongs to the earliest part of the church, and is plain, narrow and square.

A south aisle was added in around 1200, but on its south side it was rebuilt in Early English style in 1873. It has a three-bay arcade, octagonal pillars, plain moulded capitals and bases. The only old window is at the east end of the aisle, originally a lancet, until in the fourteenth century a two-light traceried window was inserted into it. The head of the window is cut from a single stone. The nave north wall has rubble masonry within its lower part and the jambs of a blocked door. The church has several roof-lines visible.

Widdrington: Holy Trinity

Widdrington church stands away from the modern settlement of Widdrington station. As the name is an early one meaning the settlement of Wudhere's people, the older village was more likely to be near the church. The church lies just to the east of the main road from Ashington to Alnwick, and is in some ways easy to miss as it stands a little distance from the road and is tree-screened.

From the south, the windows are seen to be square-headed with fourteenth-century tracery. The south door is close to the west gable, with rich decoration. Inside, the nave is shorter than the chancel and has a late twelfth-century arcade of two bays: this is the earliest surviving part of the church. The south arcade is later, mid-fourteenth century, with octagonal piers and pointed arches. The south aisle extends along the south wall of the chancel into a chapel which has a piscina (for washing communion vessels). The chancel arch springs from the east pillar of the south arcade along with three other arches. The east chancel window is small and renewed, and has flowing fourteenth-century tracery.

The north aisle was demolished, and rebuilt in the fourteenth century. Within the church are sedilia (seats), and there is a thirteenth-century cross slab above the vestry door.

Birtley: St Giles

A chapel at Birtley was granted to Hexham priory by Odinell de Umfraville along with Chollerton, by which time the building may have been in existence for some time, as a pre-Conquest stone indicates. The church has nothing earlier in it than the twelfth century, of which the chancel arch is the outstanding survivor. The chancel north wall is also Norman, with fine, squared stone, but the rest of the church was completely restored in 1884. Medieval grave slabs have survived, now built into the west porch. Nearby are the remains of a late sixteenth-century tower.

Longframlington: St Mary's

The parish church was once a chapel, first mentioned in 1196, and lies close to Brinkburn priory, which may account for the Norman features in the building, perhaps using the same masons. It has an aisle-less nave and a short chancel. Late twelfth-century features are well preserved in the south doorway and chancel arch.

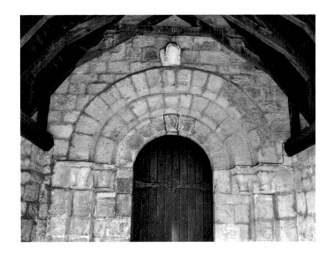

Longframlington south:
Norman doorway.

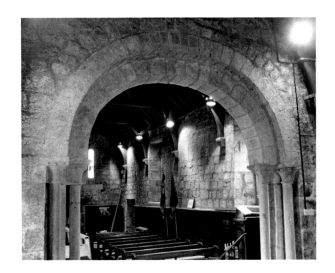

Longframlington: chancel arch.

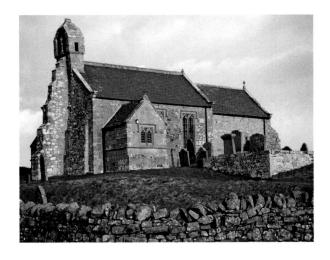

Thockrington from the south, built
high on basalt.

Originally it was tall in proportion to its width, with high windows. The north windows are modern, and there may not have been any there originally.

The doorway arch belongs to a Transitional period (like Brinkburn); it has three square orders, the capitals being Transitional. The chancel arch has two square orders supported by three pillars, which are detached, the capitals having signs of carved foliage. The porch is an addition, and so is the vestry. The north wall has a built-in fourteenth-century window, which was reused in the 1882 restoration.

Thockrington: St Aidan's

The church is today well off the beaten track, and is built dramatically on the crest of the Whin Sill – that outcrop of basalt that is followed in its central course by the Roman wall. Yet it has not always appeared so isolated, as it lies next to the faint walls of an abandoned village and in the middle of extensive series of rig-and-furrow systems that point to flourishing arable fields, now in pasture. The church is still used and cared for.

It was Thokerinton in 1223, named after a Saxon, Thocker, but its oldest feature is Norman, as we see in its vaulted chancel and the west wall of the nave. There has been extensive restoration, but the chancel fortunately survived. Probably apsidal in Norman times, the chancel was squared off in the thirteenth century. The vaulted chancel ceiling is between two plain Norman arches. In the north and south chancel are two round-headed windows made from a single stone. Outside on the east are massive buttresses to prevent the building from slipping downhill.

The bell turret gives the church distinction, is similar to those at Ford and Felton, and could be a replacement of an older one. It has a massive buttress to support it.

The Thockrington
Norman chancel arch.

Mitford: St Mary Magdalene

The church is built close to a Norman castle, which has a motte with a shell keep built later inside it. The importance of this link is that the church had to share the fate of the castle, either for the occupants of the castle to provide resources to build it, or restore it in part and rebuild it several times.

The oldest part of the church is Norman, a large building. By 1150 it had an aisled nave of five bays, with another aisle built later in the same period. The columns of this south nave are massive, its round arches springing from scalloped capitals. The bases of these are square and ornamented; three and a half of these bays survive. The east end of this aisle has a shaft that indicates that it had an arch leading into a former apse.

The north wall was rebuilt after raids by King John and Alexander of Scotland in the early thirteenth century. Later in that century, after the rebuilding of the north wall without an aisle, the chancel was built. This chapel is very large, its lancet windows separated by projecting buttresses, with a stone course along the base and string course higher up. There is a priest's door and a side window built in. Inside, the lancets are shafted, and their arches are moulded. The sedilia and piscina are of the same period.

After parts of this church were destroyed by fire, transept chapels were added during the rebuild, but the aisles disappeared. A big fire in 1705 ruined the nave, which was not rebuilt until 1870, when it was extended to the west and a tower and spire added.

Elsdon: St Cuthbert

Elsdon church is part of a settlement that includes a Norman motte-and-bailey castle that is a classic example of its type, not further developed by the replacement of wooden walls for stone ones. The church faces a very large village green that was once an important resting place for Scotsmen and cattle on their route southwards to fattening pastures in England. It also has a fortified tower that was probably begun in the fourteenth century and rebuilt in the sixteenth century. Around the village are many examples of rig-and-furrow ploughing in hollow land, and its earliest name may mean Elli's valley.

The church shows its southern face to the circular village green, built of coursed rubble and including fourteenth-century window tracery, although inside the church we see that it is much older than that, dating to the twelfth century. The nave suggests this, and there is a blocked tower arch, perhaps reset later as a pointed one. Half-piers bonded into the west wall to carry an arch are twelfth century and have carved knobs in their decoration. The two west windows of the aisles are early lancets, dating from the thirteenth century.

Unusual fourteenth-century features of the church include the narrow tunnel-vaulted roofs over the octagonal pillars and the moulded capitals to the thick outer walls. The nave arches, of four bays, are fourteenth century, but the vaults may be later. The chancel is fourteenth century, with the east end rebuilt in the nineteenth century. The south wall of this chancel has three different styles of windows, as we see as we approach from the south. There is also a priest's door. There are north and south transepts with square pillars and some carvings on them.

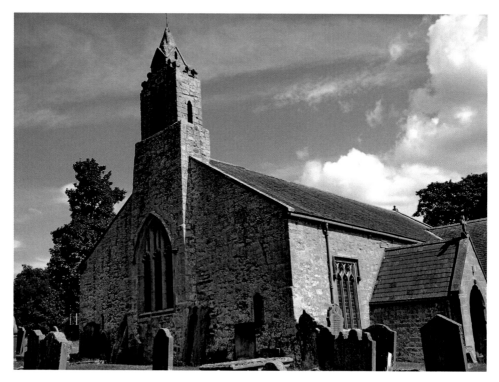

Elsdon from the south-west.

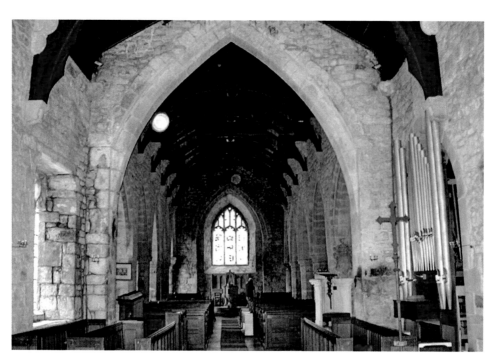

Elsdon interior.

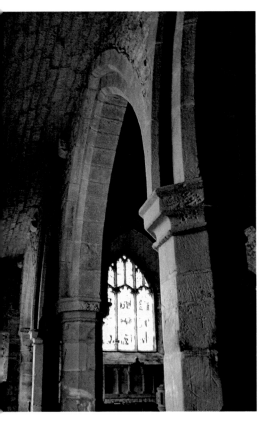

Above left: Elsdon: aisle roof south.

Above right: Elsdon: aisle roof north.

Blanchland

Dedicated to St Mary the Virgin, this was a Premonstratensian abbey, built in 1165. It was a ruin in the eighteenth century and the Lord Crewe Trustees created the present parish church from its remains. The survivals from the monastic church are the chancel (1200–10) and the transept and tower, built a century later.

Ilderton: St Michael

There was a church at Hildratun in 1121, which was attached to Kirkham priory, Yorkshire. The modern name may refer to a village on the same site. In the late twelfth and early thirteenth centuries some work was done on the church. Parts of the west gable belong to that period. It was burnt in 1296 by the Scots, and all the vicar's goods were destroyed. After that we have no record of repairs until 1578. By 1715 it was so ruinous that only the middle aisle was used, and it was roofed with turf. By 1727 the churchyard had risen 4 feet above the original floor level of the church. Thus drastic rebuilding took place. It is built of freestone with a slate roof.

Lilburn Chapel

Lilburn is named after Lila's burn, or the chattering stream. Enclosed in a five-sided earthen dyke graveyard is a ruined early Norman building consisting of a nave, chancel and a thirteenth-century chapel. Rebuilding began in the second half of the twelfth century, but only the lower part of the south wall was built until work was resumed using rougher stone and incorporating some earlier ashlar.

In 1220 the landholders could not use the church as a private chapel because it belonged to the monks of Tynemouth, so they built one to the south. It houses the Alexander monument. When the Scottish wars ended, the chancel was altered and a new floor was put in. It became a chantry. After the Reformation the south chapel was separated from the church by a stone wall, and reports show that it was still in use after 1660.

In 1734 all the Eglingham chapels were in ruins and the ground used only for burials; Lilburn south chapel was demolished but only a few of the stones were removed. In 1887 the walls were re-pointed to prevent further loss. The site was excavated in 1933 by E. F. Collingwood and dateable fragments were recorded, giving us some idea of the decoration and style of parts of the building.

The chancel arch opened into a nave; its voussoirs were found where they had fallen and were buried, and thus preserved. The decoration was chevron and saltire cross.

The nave had no window on the north side in the surviving wall; the south wall had an arch into the south chapel and the lower part of a Norman door. A Norman capital with a scalloped pattern from the top of a pillar was found. The excavation also found a dog-toothed part of a tomb slab. These were all parts of the early building.

Among the tombstones one local red sandstone slab has the name Alexander in Lombardic script; the effigy is of a knight with a shield, spear and two-edged pointed sword thought to be early twelfth century. There is a mason's gravestone as well as two thirteenth-century grave slabs, one with traces of a cross.

Bothal: St Andrew's

This church dates from around 1200, with the nave walls of that period or earlier, and the four-bay north aisle and south-east chapel are also early. The rest was developed mainly in the thirteenth and fourteenth centuries. There is some nail-head decoration, lancet windows and a 'squint' with stiff-leaf decoration in the south-west corner. There is a south chapel that was extended to the west into an aisle in the fourteenth century.

To the right of the chancel arch there is an ogee-headed (double curved) niche of the fourteenth century. The nave was originally Norman but was restored in 1911/12, with the addition of a broad north aisle.

Rock Chapel: St Philip and St James

The chapel lies between hall and village, originally a nave and chancel, restored in 1855 with an added apse. In 1866 a north aisle was added, which led to a renewal of the Norman wall to the north. The Norman building has a corbel table running round it, on pilasters

(shallow-relief columns), and the chancel arch has deep horizontal zigzags and cushion capitals. The west end has doorway with chevron and other ornament. Some critics of the restoration of this chapel have not liked the changes to the original medieval building.

Rennington Chapel: All Saints

At the south-east of the village, it is now a modern church, but the original was built as a Norman chapel. When the Revd John Hodgson visited it in 1825, it consisted of a nave and chancel. On the north were three arches which must have led to an aisle, but in 1825 they were filled in and disappeared. The old chapel was pulled down in 1831 and a new one built.

Bedlington: St Cuthbert

In 1050 the name suggests that it originates as a settlement named after Bedla or Betla, but the church today looks mainly eighteenth and nineteenth century. It occupies high ground overlooking a main road. Inside, a better idea of the age of the church is in the Norman chancel arch, which even so may have been reset. It has carved chevrons on the east side of the arch which is supported by semicircular responds (half-columns bonded into the wall). There is an ogee-headed (double-curved) niche of the fourteenth century to the right of the chancel arch. The nave was originally Norman but was restored in 1911/12 with the addition of a broad north aisle.

Bolton Chapel

This chapel of ease, belonging to Edlingham, has a Norman chancel arch, and the chancel may be built of medieval masonry. The rest is nineteenth century.

Branxton: St Paul

Branxton was named after Branoc, an Old English name recorded much later. The site of the church has become famous for its proximity to the battlefield of Flodden, and many of the dead from that conflict are said to be buried there. It looks like a modern version of a Norman church. It dates to 1849 and is built of rhyolite and sandstone. The original church was Norman, but only the jambs and capitals of the chancel arch remain, with a pointed thirteenth-century arch springing from them. Its graveyard looks towards the Flodden memorial cross on Piper's Hill, where the Scots were finally defeated in 1513, and to Scotland in the other direction.

Belford: St Mary

Rising above the village, this is an attractive church, and looks modern. The name Belford was Beleford in 1242 (a late recording) and may mean Bella's ford or a settlement at a bell-shaped hill. The village has been bypassed by the A1, giving a more spacious approach to the church. The area in which it lies is primarily agricultural.

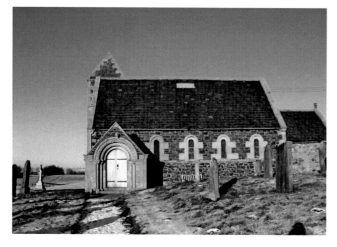

Branxton from the south, rebuilt.

With the 500th anniversary of the Battle of Flodden coming on 9 September 2013, this photograph of the church cemetery, which looks towards one of the key sites of that bloody battle on Piper's Hill, is an appropriate reminder of the conflicts the occurred in the border country.

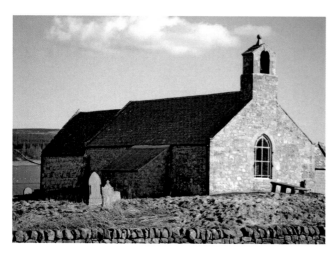

Corsenside thirteenth-century church from the north-west.

Inside, the chancel arch is Norman, with chevrons carved on the east side, with other Norman pieces built into the wall above the arch, suggesting that it has been reset. There used to be a south door of the same period, but this is now lost. The original would probably have been a small Norman chapel, which has survived only in part as the village expanded.

Corsenside: St Cuthbert

Corsenside (Crossinet in 1254) is the hill pasture, possibly named after an Irish man called Crossan; it overlooks a great stretch of pasture and hills towards West Woodbridge and the Wanney Hills. It lies off the A68 road that is on the line of the Roman Devil's Causeway, and is partly obscured by a farm to which a gated narrow road leads. The view from the graveyard is dramatic, with distant hillside quarries in abundance and rig-and-furrow systems of farming evident, showing that what is now pasture was once arable land. It seems to have settled into the landscape and become part of it. It is a plain church, with a nave and lower chancel of Norman origin, as the simple chancel arch shows.

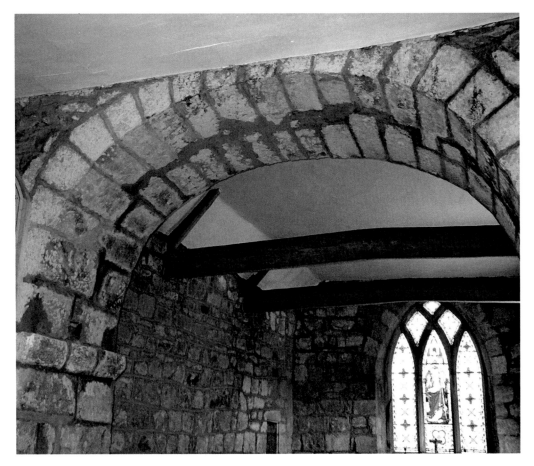

Corsenside chancel arch.

3

POST-NORMAN BUILDING

Until around 1300 there was sufficient peace along the border for further developments to take place and, as we have seen in the Transitional period, one of the main changes was from the rounded arch to the pointed one. This affected arches that led into the chancel and transepts and the rows of arches in the nave. Another feature was a change to the east end of churches as apses were abandoned in favour of a squared-off end to the chancel. The pointed arches ('Gothic') led to changes in window design and the general chunkiness of solid Norman architecture became lighter and more airy, ready for further developments in decoration.

Some churches show the remains of a continuous development from Anglo-Saxon through Norman to Early English, but I begin with a church that is very much of the thirteenth century.

Haltwhistle: Holy Cross

The church lies to the south of and below the main street on a shelf of land that has wide views over the River Tyne to the south. As a market town, Haltwhistle has also been at the centre of the turbulent border area, as we see in the number of surviving and documented fortified 'bastle houses'. It has also been an industrial area, making use of coal, lime and dolerite, and is on the line of communications from east to west, including the railway. Its name means a high place bordered by two streams.

The church is built of iron-stained sandstone, in not very large blocks, and is a well-preserved example of Early English style, basic and austere. The aisled nave is tall, carried into a narrow chancel. Although the church was restored in 1870, the tall, narrow lancets were respected, and these are what gives the church such a single-period look. There are thin buttresses to support the walls, apparently original, which taper towards the top.

The restoration is obvious due to the use of new stone, and a vestry was added to the north. The west-end lancets are very tall and replaced whatever used to be there; the bell-cote was added at the same time. There are repairs to the stonework, but the general pattern of thin coursed stones gives the impression that very little has changed, especially from a distance. Although very close to the Roman wall, the material seems to have been quarried rather than recycled from that tempting source.

During raids, the church may have been a place of refuge for those who lived in flimsy houses in or around the town.

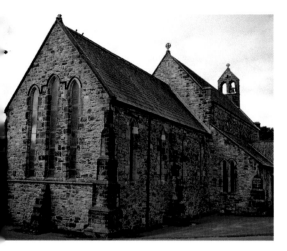 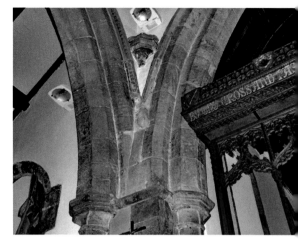

Above left: Haltwhistle from the north-east.

Above right: Haltwhistle arches.

Morpeth: St Mary's

The site of the church on the north side of the River Wansbeck is part of the Norman past, for it adjoins the site of two castles – one at Ha'Hill with a large motte, and the other close by, possibly begun in the thirteenth century by the de Merley family, with some stone walls remaining. The rest of the settlement is on the north side of the river.

The church lies on rising ground at the road entrance to the town and stands prominently within its large graveyard. Noticeboards describe it as Norman. It may have its origins in the castle-building period, but the present building is predominantly fourteenth century. From its approach through a lychgate, the church has a higher pitched roof over the chancel that greets the visitor and presents a splendid fourteenth-century window, which, we see inside, contains some original glass. The aisle and nave roofs are lower, and just above them is a square tower with diagonal buttresses. The whole is built of attractive light sandstone, and its windows let in plenty of light.

Aisles were added to the nave on either side with arcades of pointed arches. The tower that opens up directly into the nave has a vaulted ceiling. A large pointed arch leads from the nave into the chancel, which is lighted in the east wall by the 'Jesse window'. The south porch, the main entrance to the church today, is round-headed and has an added sixteenth-century porch.

Inside and outside the church there are many original features. The Jesse window is reticulated with five lights (smaller windows inside the main arch), a pattern that is repeated in the nave aisles. On the outside of the east wall, the buttress that supports the south-east corner has two niches, one on top of the other, for images. On the south side of the chancel there is a priest's door with original hinges, dating to 1350–1400, and there is a low side window (thought to be for observing the service from the outside of the church). Of the same period, the south door has its original hinges and knocker. We enter through this door with the tower on our left, and

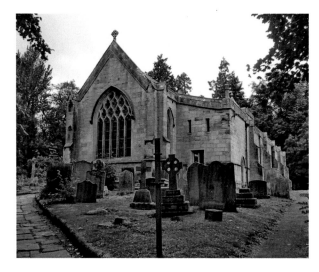

Morpeth from the north-east, with
niches that may have contained statues.

Morpeth: priest's door on the south side.

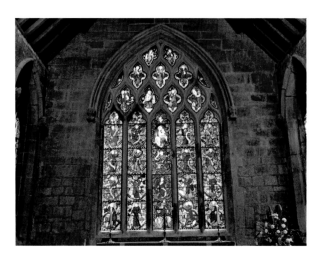

Morpeth: the Jesse window.

as we turn toward the altar along a central aisle we have arcades of five bays on either side. The arches stand on octagonal piers, those on the south having closely clustered leaves as decoration. The vestry is of the same date as the chancel, built in two storeys. The gargoyles on the west wall suggest that it was once an external wall with two windows.

Access from the church to the town is now through well-planned and attractive paths, leading to parkland and the river. Across the bridge is the chantry – another part of Morpeth's church history, while on the road west out of the town are the fragmentary remains of Newminster Abbey. Chantry and Newminster Middle Schools are named after them.

Stamfordham: St Mary's

The church is the oldest building in the village, lying at the west end of the long village green, along which the mainly eighteenth-century houses run. The church occupies a high point where the ground drops sharply away to what was once swampy ground, emphasising the height of the tower. The village name refers to its position as a stone fording place over the River Pont.

It is immediately clear that there has been considerable restoration of the fabric, and the effect is well-ordered and impressive in a thirteenth-century style. The tower, however, has genuinely thirteenth-century features, dating from 1200 or earlier, and there are some signs that it may have started life in the Saxon period; a blocked arch in the west wall of the tower is either Saxon or Norman. An Anglian cross-shaft found in the church is now at Durham Cathedral, but this is no evidence for an earlier building. The tower looks very solid and strong. The lower floors have lancets (pointed windows) of that period and a double pair high up in the south wall. There are no angle buttresses on the tower; it was built in four stages, with string courses marking them. The large buttresses are additions to cope with the steep western slope of the land. The entrance from the tower to the nave is a steeply pointed plain arch.

The long, thin chancel has been restored, and there are quoins at the south-west that may be Saxon. The outside of the chancel wall has incorporated reused older stone and replaced oblong windows near the porch with lancets.

Other indications of use of the building at different times come from the broken statue of a knight of the fourteenth century and a crucifixion scene on part of a reredos (altar screen), crudely carved in the fourteenth century. Otherwise, restoration has absorbed any other old features, but left an attractive place of worship – incidentally, with some interesting eighteenth-century gravestones. Rectors are recorded from the late twelfth century, and the church was largely rebuilt in 1848.

Bellingham: St Cuthbert's

The earliest form of the name is Bainlingham, in 1179, which might mean either the settlement of the hill dwellers or of a man named Bel. The church, its earliest visible features being Norman and early thirteenth century, has been subject to sweeping changes in its restoration, yet manages to look medieval. It is named after St Cuthbert, who was supposed to have performed a miracle there. This is linked with the water in St Cuthbert's, which stands well below the level of the church on level ground above a stream.

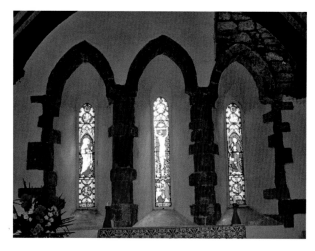

Bellingham: east chancel thirteenth-century windows.

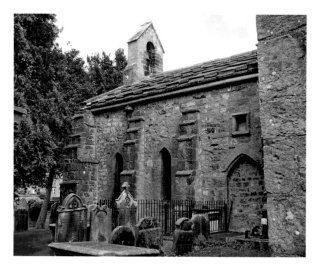

Bellingham: the south-east exterior, largely restored.

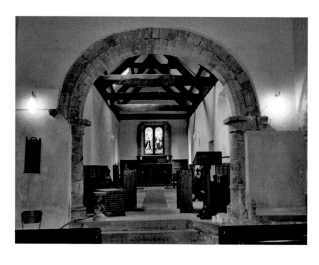

Alnham: chancel arch.

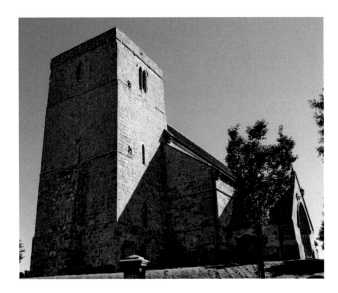

Stamfordham church from the west.

Whatever may have been there before the late twelfth century was demolished; the new church on the site consisted of an aisle-less choir and a nave of four bays with narrow aisles on either side. There was no tower. Some early masonry remains in the chancel where there are three lancet (pointed) windows of the thirteenth century at the east end and on the south side. The nave arches were then removed, but the four responds remained embedded in the walls, with parts of the hood moulds springing from them. These responds are thirteenth century and have nail-head decoration. There is still a south transept, where there were two chapels divided by screens and accessed by a porch.

Bellingham lay at the centre of a turbulent region in the Anglo-Scottish wars and Reiver raids, so it is no wonder that the church fell into ruin. After 1609, what was left of the roofless ruin was largely demolished, and the aisles disappeared. Then followed a restoration, the most remarkable features of which are the vaults for nave and transept, made of heavy slabs laid on massive ribs. This is what makes the whole church look medieval.

The seventeenth-century roof is like that at Ladykirk, across the river from Norham, built by James IV of Scotland. After further decay, repairs were made in 1865.

Alnham: St Michael's

Until 1870, the church was in ruins. It is situated in an area that was important in prehistoric times and is on the route of the Salter's Road from the Cheviots to the Vale of Whittingam. The oldest fragments of the church are a few large Anglian quoins at the south-east and north-west corners of the nave. In the late twelfth century the church was given to Alnwick Abbey. In the Transitional period it acquired a new choir, chancel arch, south chapel, north aisle and west front.

The church was greatly enlarged in the reign of Henry III, a boom period for Alnham. The north Norman arcade was replaced with pointed arches, and the north aisle made wider. Then came the reign of Edward I and the destruction of so much in the Anglo-Scottish wars.

Alnham: north nave wall with
blocked chancel arches.

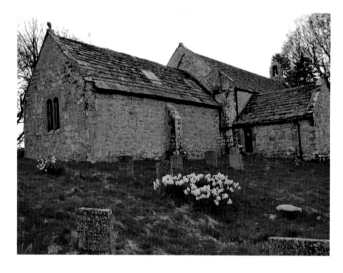

Alnham from the south-west.

Alwinton from the east.

Sometime in the fifteenth century, the south wall was repaired and raised by three courses. An arch was built into the south chapel, the north arcade removed and the aisle removed, which accounts for the appearance of pointed arches as an arcade being seen from the outside, all blocked up. There was a drop in population that must have accounted for this shrinkage. Original features can also be seen in the transept arches, parts of the west window, and a fifteenth-century recess in the south chancel wall.

Outside the church are all the signs of the importance of an ancient settlement. The fields rising to the west unmistakably show the walls and enclosures of a destroyed castle and its grounds, and the vicar's defensive tower is nestled outside the graveyard wall.

Alwinton: St Michael's

Built of freestone and slate on a sloping site, the church has a superb setting within a sparsely inhabited area on the edge of the Cheviot Hills, where the River Coquet runs from the north-west and turns south. The slope is so great that the floor level of the church rises dramatically from west to the altar. Although it is almost entirely rebuilt, it retains great charm.

John Hodgson's sketch shows the church in 1820, before it was rebuilt in 1851 in the Early English style. The only remaining parts that predate this restoration are the chancel (which has one small twelfth-century window), which was altered in the fourteenth century, lancets in the west wall, and parts of the north aisle. The crypt was added and the floor raised above it. The area was vulnerable to raids, and there were periods of destruction and repair, but the greatest destruction – which writers speak of as 'a catastrophe' – was the destruction of the nave and the taking down of the early church arch in the nineteenth century.

Whalton: St Mary Magdalene

The spelling of the name in 1203 suggests that it comes from Old English *hwae-tun*, meaning a farm on a hill. From the church there is an extensive view across the county to the west and south west, and it is approached from the estate village by a path high above a sunken road on the east. A large graveyard surrounds the church, which is an imposing building of sandstone and millstone grit, dominated to the west by its high tower, which is similar to those along the Tyne valley and at nearby Bolam.

Outside, the stone is clean and well-restored, with a new porch giving access from the south. Inside, the age of the building becomes more obvious, and one is drawn at once to Norman and Early English features. The stone is mostly free of rendering, and the flagstones have some interesting natural patterning. The nave is tall, flanked by arcades of arches and a chapel. At my last visit in 2010 there were still some parts where stonework was being treated and restored; such large buildings are a liability for small communities today, whereas in the past, as we see in the memorials, local rich people made big contributions to the church's upkeep.

The tower appears to be Anglo-Saxon, dating from the eleventh century, with unrestricted entry from the nave, but above that a ladder would have been needed. The first floor has no windows, and the second and belfry stages have very narrow ones, the top part being reconstructed in 1783.

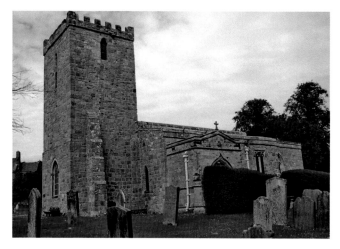

Whalton from the south-west.

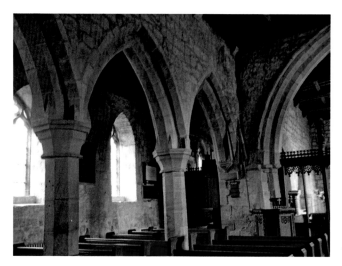

Wharlton: north aisle.

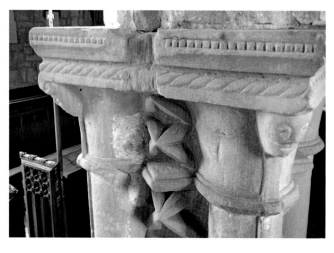

Wharlton: Norman ornament with
stone heads supporting the capitals.

From the tower there ran a Norman arch. Now there is only a half drum remaining in the wall, as the whole interior was remodelled in the thirteenth century. This Early English period has left the west lancets of the aisles and very low lancets on the south aisle wall. The arcades are of the same date; they are of three bays supported on octagonal piers with simple capitals. The thirteenth-century chancel arch has nail-head ornament on its responds, and is capped by a hood that ends with dragon motifs at the ends.

From the chancel there is a southern two-bay north arcade leading into the Ogle chapel, which has round arches on a central pier that includes vertical dog-tooth ornament and carved masks at the top. The arch from the chapel to the north aisle has nail-head ornament on its responds.

The south wall of the chapel has a piscina, traces of blocked openings and sedilia. Some of the windows are fourteenth century, with reticulated tracery, but many other windows of the church are 'restored'. The recess in the south wall for a tomb has a thirteenth-century cross-slab inside.

Rothbury: All Saints

This church is a sad example of what injudicious restoration can do. The rebuilt church bears little relationship to what we see in old etchings, so although it makes a pleasant place of worship for today's congregation, it has lost much of its history.

The name is Old English, and either means Rotha's fortification or the red fort if it comes from the Old Norse *rauthr*. The first reference to the church is in 1090 when tithes were granted to Tynemouth Abbey. These tenths of local produce and value were for centuries claimed by churches to pay for the 'mother' establishment. In 1122 these tithes were in the hands of the prior and convent of Carlisle. The first named rector was Richard d'Orival, in 1107; he was Henry I's chaplain, who also had the livings of Warkworth, Chillingham and Corbridge to support him.

However, the church site seems to have been important before the Conquest, if the magnificent Anglo-Saxon cross found there is anything to go by. This cross, part of which remains in the church as part of the font, while the other part is in the Great North Museum, is likely to have been made in the first half of the ninth century, making it the earliest surviving stone cross (rood) in the country.

All of the church excepting the chancel and east walls was destroyed in the 1850 restoration. Originally there was a Norman tower that linked two churches, its north and south arches opening into transepts that projected from it. Two naves to the east and west were separated by this central tower, which we see in the old views. The story is that the south side of the eastern church was rebuilt in 1200 with an arcade and side aisle, then a north transept chapel was built. The choir was later rebuilt with either an aisle or chapel on the north, and a chapel was added to the east bay of the south aisle. In the fourteenth century the chancel was rebuilt after the Scottish wars.

So what old parts are left? The earliest parts are thirteenth century, such as the chancel with its priest's door, and there are six lancets (two replaced) on the south wall, and triple lancets on the east wall. The east wall of the north transept has three lancets. The chancel arch is chamfered. The modern north arcade still has a thirteenth-century shafted corbel with nail-head ornament, but there is very little left of the original building.

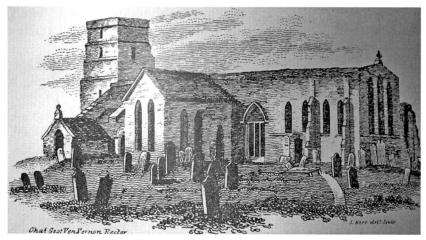

Rothbury in 1823.

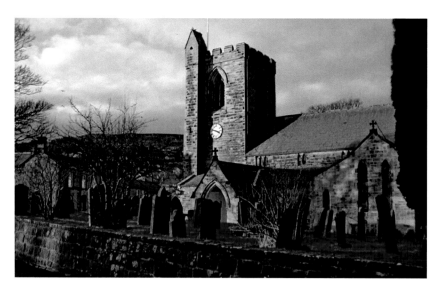

Rothbury church today.

Ingram: St Michael

St Michael's church is on a level piece of ground beside the River Breamish, at a very attractive entrance into the Cheviot Hills. The church was much restored in the nineteenth century, but no accurate records of this were kept, which makes it difficult to trace exactly what happened. The nave and the chancel were much larger in medieval times, and there was a wide north aisle and a north chapel. We know that the church was restored after a Scottish raid.

All the earlier work is the lower part of the west gable on either side of the tower arch. The tower was rebuilt, but the use of old materials point to its being built in Anglo-Saxon times. An enlargement of the church was made in the thirteenth century, before the Scottish raids began. The chancel arch was renewed, with north and south chapels opening into the nave. Later the nave was given side aisles, their pointed arcades being designed to fit three bays. The tower was then completed with a stone spire and a parapet around it.

In 1296 it was burnt by the Scots, and in 1663 it was declared 'ruinous and destitute'. The south aisle was demolished in the early eighteenth century. The spire was later demolished and a complete restoration in the thirteenth-century style was made from 1877–79. So, although little of the original churches remain, what is there today is still attractive – and used.

Hartburn: St Andrew

This large church, perched above the Hart Burn, has recently been disturbed and surveyed for the introduction of a new underfloor heating system. Work revealed disarticulated human bones spread under the nave paving stones, and external trenching to the west of the tower has uncovered hitherto unknown walling, which could not be further explored under the terms of the archaeological watching brief, but which from the coursing may be Roman. The site is the crossing point of the Roman Devil's Causeway road through a hollow into the burn. The settlement of Hartburn used to be more extensive, and there are faint earthworks that indicate an abandoned village.

Although the remains are scanty, the earliest masonry in the church is Anglian; the nave has quoins from that period. However, the church, like so many others, shows change over hundreds of years. A strong feature is the three-stage tower, which dates from the twelfth or thirteenth century. The blocking of this tower to the nave is post-medieval, but the nave itself has a thirteenth-century arcade of pillars and arches. The south porch is of the same period.

The church looks predominantly thirteenth century, but its north chancel wall was rebuilt in 1832. From the outside this wall looks bleak and fortress-like, as it has no windows. Windows in the church are of the lancet (pointed) type, and those to the east are separated by buttresses on the outside and tall shafts on the inside. In the nineteenth century various small restorations were made to some windows and buttresses.

The settlement at Hartburn was large, and beneath the ground there must be many features of interest to the archaeologist. The high quality of the eighteenth-century headstones indicates a prosperous area.

Newbiggin-by-the-Sea: St Bartholomew

An etching of the church around 1830 shows it to be partly in ruins; today the restoration continues with the addition of a new eastern stained-glass window, making this a most attractive and well-loved church. It is also old – possibly more so than even the oldest visible part today indicates. Its position on a promontory into the sea and its dramatic view along a curving bay suggest – without further evidence – similarities with Anglian monastic sites.

The most obvious feature as we approach from the town is its spire growing out of a tower – a rare occurrence in Northumberland. But as we move to its south side, the great length of the nave and chancel is another surprise. As we enter we see that the nave had long aisles on both sides. Outside the building is an attractive light sandstone that can be easily eroded, something that we see with dramatic effect on worn graves of the same material, where they are exposed to whatever the coastal weather can throw up. A study of the stonework shows

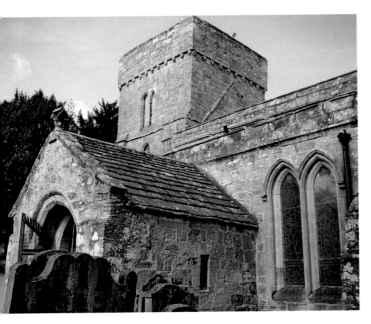

Above left: Hartburn south.

Above right: Hartburn: nave and chancel.

Below: The large interior tower arch.

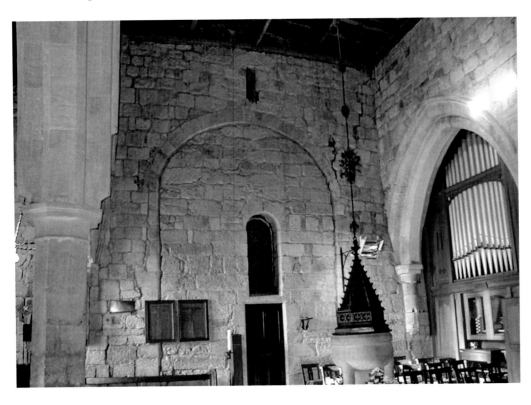

how many repairs and renewals have been made. For example, built into the outside east wall are pieces of medieval grave slabs used as building material.

The tower is one of the best original features, and it was remodelled in the thirteenth century. Its impact has been achieved through the addition of a spire, without a break from one to the other, making it 'grow' naturally.

In the nave there are some reset stones with geometric patterns, and one wonders where these came from. Another stone, a capital, is reset as a bracket at the east end, but the chancel arch itself is a modern restoration. The nave arcades have survived, although the aisles have gone and the chancel has lost its roof. This chancel is thirteenth century in origin. It may have been added to an existing nave, making the church even longer. The pillars and capitals have a thirteenth-century date, made particularly clear by the billet and floral decoration.

Part of the restoration of the church at different times has made use of medieval grave slabs of high quality and decoration, thus preserving them.

Bamburgh: St Aidan

Bamburgh is famed for its gloriously restored castle high on a whinstone outcrop overlooking the sea to the east and the village, which is on sloping ground to the west. Bede says that St Aidan had a wooden church near the royal buildings on the rock, originally established by a war group from Northern Europe. Bamburgh is named after Bebba, one of a handful of noble women who gave their names to settlements at this early stage. Bamburgh was a very important power base in northern Britain.

Despite its importance, there is nothing pre-Norman in the church, and it seems unlikely that there was a stone church then. However, Symeon of Durham says that a chapel there was of beautiful workmanship and that it had an ornate shrine of St Oswald. We learn also that his arm was stolen from here by a monk, Winegot of Peterborough. The present church dates from the Augustinian rule and housed canons.

The large building is varied from the outside, and was begun in 1230. It had an aisle-less nave, north and south transepts and a chancel, the latter being particularly fine. Although there are north and south transepts, there is little of the original left other than the south part of the east wall of the north transept and a little walling in the south. The chancel arch shows the width of the nave, leading into a fine chancel with a high-pitched roof that contrasts with the rather flat roofs of the rest. The chancel remains aisle-less, and at the east has three equal lancet windows separated by buttresses. Outside, on the south, are lancets, all but one paired, with a dripstone linking them. Above them is a parapet resting on corbels. Outside, the land slopes sharply to the east, making the large wall, windows and crypt well visible. The interior of the chancel is rich.

The north aisle has four bays with circular columns. When the south aisle was added it was not of such good quality, with its four bays of equal height and width, circular columns with plain capitals, and a clerestory above with square-headed small windows. The south aisle is particularly wide, making the south transept look small as it absorbs it. This widening may have taken place in the fourteenth century; this could be a result of more people using the church.

Newbiggin: the spire seen from the dunes.

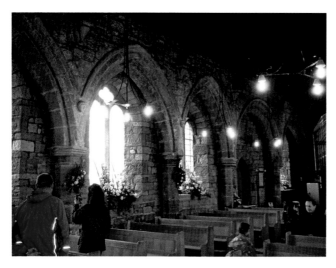

Newbiggin: south aisle during the 2012 Flower Festival.

Bamburgh church, west from the castle.

Kirkwhelpington: the west tower.

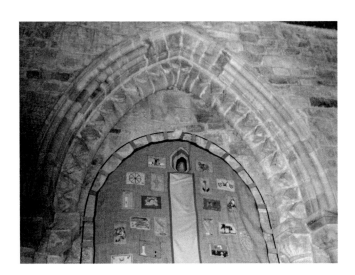

Kirkwhelpington: the blocked interior tower arch.

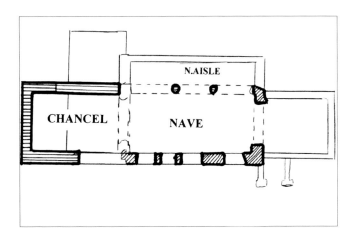

Doddington plan.

Kirkwhelpington: St Bartholomew

The element 'kirk' means that there was a church there. In 1182 it was simply Welpington, Hwelp's named settlement in Old English. The area in which it lies has deep rig-and-furrowed fields, indicating arable use before it was turned into permanent pasture, making the church a focus for an agricultural community that was even earlier. Iron Age hut circles have been excavated at an expanding nearby whinstone quarry site.

The tower captures our attention first: squat, heavy and well-buttressed to correct structural weaknesses. This probably belongs to the Perpendicular period, as we see of the bell openings and its west door. The nave, entered at the thirteenth-century south door, is long and there are no aisles. It leads into a thirteenth-century chancel. The doorway has nail-headed decoration. As you enter the church through this doorway, you will see to the left that the west nave arch is steeply-pointed, with scalloped capitals and zigzag decoration. This presents a problem, as it was too big to be an entrance before the tower was built. Its filling also includes Norman and thirteenth-century work from the restoration of the church in 1896. Perhaps the tower was older than it seems. Excavations have shown that there were transepts.

Doddington: St Mary and St Michael

The village of Doddington, which means either the settlement of Dodda's people or hill settlement, lies at the foot of the Fell sandstone scarp that runs from north to south, facing westward, a distinct geological boundary between the dried-up glacial lake of the Milfield Plain and the land behind the scarp that dips east towards the North Sea.

The church appears very odd at first, as the altar is to the west. Its earliest foundation is early twelfth century, but the rest is thirteenth century. Originally there was a nave and chancel, with a west tower, but the chancel was replaced in the nineteenth century by a new one to the west where the narthex used to be, and a vestry was added there on the north side.

There is little pre-Reformation documentation, but we know that it was a chapelry of Chatton parish and that it lay on the front line of Scottish raids. The west tower was demolished early on. A narrow aisle was built onto the north side of the nave, which was possibly abandoned in the early eighteenth century along with the choir. A burial vault was built under the floor of the west narthex, raising it 1 metre above the floor level. The old chancel arch has been entirely reconstructed, the nave walls raised, new windows put in during the nineteenth century, and the floor re-paved.

What we see today is a north nave aisle that is mainly thirteenth century with large capitals, forming a three-bay arcade. The rest is modern. The oldest masonry is possibly twelfth or thirteenth century. Several thirteenth-century tomb slabs have been used as building material, and the lowest part of the 1723 font in the baptistery (once the choir) is Norman.

Chollerton: St Giles

The church is remote from any village settlement, but its name suggests that it was originally in a village belonging to Ceola. Chollerford, nearby, was in a gorge. From the outside the

church looks modern, but inside there is a nave lined with rounded one-piece pillars that appear to be Roman, probably recycled from the fort of Chesters nearby. Similarly, one font is a reused inverted Roman altar. The aisles that are formed from these piers are of four bays each. The west wall, with an eighteenth-century tower attached, is Norman. The south aisle is Norman, the bases of the pillars are moulded, and the capitals are square. The north arcade was added years later, with octagonal piers from the fourteenth century and matching capitals.

The building was restored and added to in the eighteenth and nineteenth centuries, with some medieval material built in, such as three headstone crosses in the north chancel wall, and some reused decorated stone in an external buttress on the south side of the nave.

Chollerton from the south, restored.

Chollerton: the possible reuse of Roman pillars.

Alnmouth: St John the Baptist

This church was still standing to its full height close to the sea and the Aln estuary, although it was roofless. Today a little has been preserved, but the last original part was blown down in 1806. It is worth recording that it appeared to be Norman, but some parts may have been earlier. A pre-Conquest cross was found there. A change in the river direction made the church unusable, and there is nothing of substance on the site now.

Ovingham: St Mary the Virgin

Ovingham's tall tower appears even higher because the church was built on a platform on rising ground above the River Tyne. This level area is surrounded by a big oval graveyard, characteristic of the Anglo-Saxon period. The names Ovingham and Ovington include Offa, and both places would have been named after his people or descendants. The '-ingham' element is pronounced '*in-jm*', like others in the county with the same ending. The history of the settlement, never a large one, has been well documented (Atkinson).

The site of the village, now linked to Prudhoe by road- and footbridges, was a fording place and on an important east–west route following the river valley. The late Saxon tower is the earliest part of the church. It rises to three quarters of its height before it is slightly offset, with a string course to mark this below the belfry. Like other Saxon churches in the valley, it is tall, thin and unbuttressed, rising from large quoins at the base, which become smaller higher up. The stones of the church tower vary between the very large long stones that form the quoins, placed in alternate long and short patterns, and the smaller blocks that appear to have come from Roman sites, recycled, and arranged in horizontal courses between the quoins. On the south side, below the tower's top storey, marked by a horizontal stone string course, is a puzzling doorway that would have required a rope ladder to reach it, if that's what it is. Above is a pair of windows like those at Bywell St Andrew's, with rounded tops, divided by a recessed moulded pillar, and an arc above containing a porthole-like window. Nearer the ground on the same face is another window with a solid stone arch at the top. Other windows of the same period light the top storey and the stairway.

Although some faces of the tower are partly obscured by later building, the plan of the unbuttressed tower is clear. A hint of the Saxon nave projects from the later external nave wall in the south-east corner of the tower. Inside, the tower arch into the nave is obscured by the organ, and there is no sign of an external west door in the tower.

It is just about pre-Conquest. Openings for the bells are like those at Bywell. There is no doorway from the west, and the inner entrance into the nave is about 1200. The south-west quoins of the nave are Saxon, but the rest of the church was entirely rebuilt in the thirteenth century, and since then only a vestry has been added.

The major rebuilding that we see belongs to the thirteenth century, although the porch door shows that there was Norman building at least in the late twelfth century. As the church lies close to Prudhoe, with its Norman castle, it is likely that some building was done on Ovingham church. It may be supposed from other churches that the early Saxon building was tall, with a long nave ending in an apse at the east end, perhaps with transepts, but the whole has been overlain. Most of what we see today is Early English, a thirteenth-century

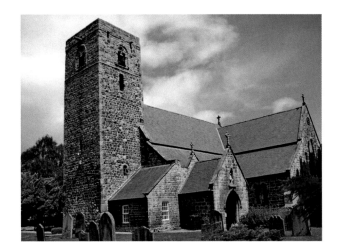

Ovingham from the south-west.

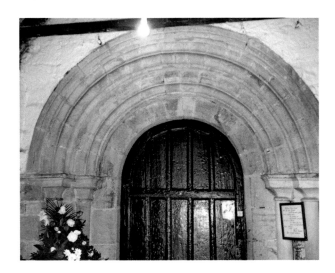

Ovingham: Norman doorway.

Ovingham: decorated thirteenth-century corbel in the south transept.

rebuilding on a Saxon and Norman site. Thanks to judicious nineteenth-century restoration, which began work on a very decayed building, it is splendid.

Rebuilding began with the chancel and transepts in around 1200, followed by nave arcades and aisles. The walls above the arcades are unusually thick, and may be earlier. When the new nave was ready, the rest of the church was destroyed. A notable feature from the thirteenth century is the buttressing.

Basically, the nave is flanked by pillars and capitals that support arcades of pointed arches; before the chancel arch is reached, transepts branch out like the arms of a cross to the north and south. The crossing piers are octagonal. A strong characteristic is the number of tall lancet windows, supported by tall, thin buttresses on the outside. Inside, these windows splay out to admit more natural light.

One puzzle is that a profusely decorated capital between the nave and south transept, from the fourteenth century, has either lost it floral decoration on the west side or never had it. There is a wash basin (piscina) in the east wall of the south transept, probably for use in a chantry chapel where prayers were said for the dead, and in the chancel are two sedilia facing north by the altar. Also in the south transept is a decorated corbel with a zigzag pattern, also of the Early English period. Elsewhere, the circular font is thirteenth century. There is a link with Hexham priory in that a rector and priests of this Augustinian order there were appointed to Ovingham rectory to conduct services in the chantry in the south transept.

There are many early fragments of stonework that have survived from early buildings, including some interesting and varied grave covers in the porch. At the foot of the pulpit, in 1945, a damaged carved stone was discovered depicting a hunting scene. In the Museum of the North is the Ovingham 'Tetracepholos' – a round stone decorated with four heads, which appears to be pre-Roman.

At the Reformation, one period of the history of this church came to an end when the Augustinians at first refused to accept the dissolution of the Hexham priory. A show of force was led by the Master of Ovingham, who appeared on the priory roof dressed in armour. He was hanged.

This church had lived through the destructive border conflicts that ruined so many churches and prevented further building, and the present fine condition of the church is testimony to the people who have cared for it since.

Mitford: St Mary Magdalene

The church is built close to a Norman castle that has a motte, with a shell keep built later inside it. This meant that the fates of the church and castle were intertwined, as the church would need the occupants of the castle to provide in part resources to build it or for it to be restored in part. It has been rebuilt several times.

The oldest part of the large church building is Norman. By 1150 it had an aisled nave of five bays, with another aisle built later in the same period. The columns of this south nave are massive, its round arches springing from scalloped capitals. The bases of these are square and ornamented; three and a half of theses bays survive. The east end of this aisle has a shaft that indicates that it had an arch into a former apse.

The north wall was rebuilt after raids by King John and Alexander of Scotland in the early thirteenth century, and later in that century, after the rebuilding of the north wall without an aisle, the chancel was built. This chapel is very large, its lancet windows separated by projecting buttresses, with a stone course along the base and a string course higher up. There is a priest's door and a side window is built in. Inside, the lancets are shafted; their arches are moulded. A sedilia and piscina are of the same period.

After parts of this church were destroyed by fire, transept chapels were added during the rebuild, but the aisles disappeared. A big fire in 1705 ruined the nave, which was not rebuilt until 1870, when it was extended to the west and a tower and spire added.

Old Haydon

The old church at what is now Haydon Bridge is now abandoned, and lies to the north of the present village, with only the chancel and chapel remaining. It was preserved, but is now regarded as 'at risk'. It used to be the centre of a medieval village until the settlement moved closer to the river when the bridge was built. C. C. Hodges restored the church in 1882, but the chancel is Norman and the chapel fourteenth century – the latter with a two-light Decorated-period window.

Ford: St Michael

Another example of a church alongside a castle, St Michael's, is largely restored. It looks to the west over the site of an earlier village to the Cheviot Hills. It is higher than the 'vicar's pele' defensive tower that is the only part of the old village to survive. The present village, to the east, was largely the creation of the Marchioness of Waterford.

Within the restored church is evidence of the thirteenth century, and the building has a strongly built bell-cote to the west that stands as a dominant feature, supported by a large

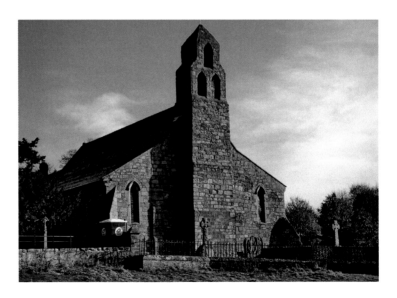

Ford: largely restored.

buttress (see Felton and Thockrington). The bell tower on this has lancets on four sides. Then above that is another stage with one lancet, and its roof ends as a pyramid. There is a nave and long chancel. Other signs of its past disappeared in Dobson's restoration of 1853.

Embleton: Holy Trinity

The church's earliest foundations are Norman, and the first recorded rector was there at the end of the twelfth century. The building, lying west of the village, has a nave, two aisles, clerestory and an added chapel.

The lower stones of the tower suggest a Norman date (*c.* 1100). The first stage is visible in two rounded, narrow windows in the north and south walls, but the early upper parts are fourteenth century. The aisle arcades probably mark where the Norman nave was. Next in age are the capitals that support the modern chancel arch, with late Norman or thirteenth-century carvings on them.

In around 1200, aisles were added north and south of the nave; after that, from around 1330–40, they were rebuilt and extended, being made wider, joining the west tower, and a chapel was added. The chancel and its arch were replaced in the nineteenth century, but the stone above it is old. All the windows were renewed, probably as copies of the originals. The nave aisles were built at roughly the same time, with arcades of three bays, octagonal shafts (or pillars) and decorated capitals. The hoods of these arches have nail-head ornament. To the north they end in spandrels with carved heads, which are modern, and on the south they are decorated with foliated crosses. The clerestory on each side was built in 1330–40, and here the windows are old with modern tracery. There is an addition to the north aisle, projecting to the north, which is used as a chantry. There may have been two others at the east end of the north aisle.

The south porch walls have several medieval men's and women's grave-covers built into them, and the door has probably been re-cut. It is most likely medieval. Above the door is a demi-angel with wings spread, and above that is a richly-decorated niche. Restorations in 1850 and 1867 have obviously changed much, but the church looks finely built.

Ellingham: St Maurice

Ellingham is a large township. We know from documents that there was a church in the twelfth century, but the present one is almost entirely modern. Built on a promontory, the name of the area around it means that it was Ella's people's settlement. Only the head of a lancet window in the east wall of the south transept and a piscina in the wall south of the altar survive from an old building, which after 1604 had decayed after the lead roof had been removed and was replaced in 1805. That building was so badly done that it was decided to entirely rebuild the church in the Early English style.

Meldon: St John

The small church has a nave and chancel in one unit, in the style of the thirteenth century. It was restored by Dobson in 1849. In a rural setting, its congregation must have been small. The east end has three original lancet windows.

Eglingham: St Maurice

The origin of the village name is Old English and means that it was settled by Egwulf's people, not to be confused with Edlingham. The church, Norman at its earliest, was granted to Tynemouth priory between 1106 and 1116, but no traces of this church exist. It then belonged to St Alban's, the parent house of Tynemouth, and it was about this time that the choir was rebuilt. The north wall appears to be late twelfth or early thirteenth century. The nave was possibly rebuilt in the thirteenth century, and then the west tower was added. Its closeness to Scotland led to it being sacked by the Scots in 1596, reminding us that the Battle of Flodden in 1513 did not end all hostilities.

The church is built of well-cut freestone with some older stone mixed in; it was repaired in the seventeenth century and again in 1826, when the vestry was added, thus its appearance is a mixture of medieval and modern. It has an aisle-less nave, but when this was built is not known. The chancel is late twelfth century, with seventeenth- and eighteenth-century lancets built into the old wall, and the tower is thirteenth century.

Shilbottle: St James

There is more nineteenth century in the Decorated style than anything else; as the church was built in 1184. Among the vicars listed is Richard, chaplain 'of Siplibotle'. The site owes its name to the Old English 'Shipley' people, and there is a very good hand-painted map in the Duke of Northumberland's collection that shows it in the seventeenth century, with all the outlying fields named. There is a reinstated twelfth-century south door with its arch resting on colonnettes (small shafts), and the former chancel arch was reused as an arch into the north transept.

Kirknewton: St Gregory

'Newton' means a new settlement, and 'kirk' means that there was a church there. The site is in a valley among the northern Cheviot Hills and is close to the site of Yeavering. The church has a lovely colourful tower made of a mixture of local rocks and a reused medieval grave slab, but it is modern; like the outward appearance of the rest of the church, this is a nineteenth-century building. Inside, the chancel has a low-pointed barrel vault that would be at home in a defensive tower. The south wall of the chancel, built of old stone, has a priest's door and small square window. The south transept also has a tunnel vault that reaches the ground instead of being supported by a vertical wall.

It is difficult to date precisely this old part, and the church as a whole was rebuilt by Dobson around 1860 in a general thirteenth-century style. However, there is a very interesting piece of sculpture preserved from the twelfth century known as 'the Kilted Magi' locally, in which the three kings bring gifts to Mary and baby Jesus, either hurrying or about to fall on their knees. The 'kilts' are the kind of skirts worn by men generally, and the composition looks somewhat Pictish. The roots of this church are certainly ancient.

Among the monuments in the church is a large slab with an incised inscription of 1485 to Andrew Burrell and his wife.

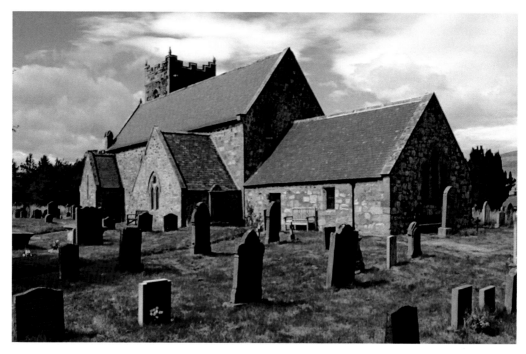

Kirknewton from the south-east.

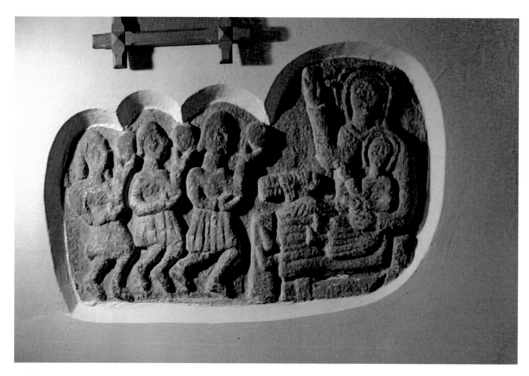

Kirknewton: the Magi.

Lesbury: St Mary

The church is difficult to interpret because there has been so much restoration, but some of the interior features are twelfth century, such as the lower courses of the tower and the jambs of the narrow, later chancel arch; the tower arch is double-chamfered and the arcade pillars are circular. Possibly a Norman church was remodelled in the thirteenth century. The east end has a large window of three lights cutting an earlier string course.

Originally a mother church, this function was taken over by Alnwick and Alnmouth, and this is perhaps why a south aisle was not built. There are Percy emblems carved on the fifteenth-century font.

Simonburn: St Mungo

This very small settlement (Old English: Sigemund, his stream)` was recorded in 1229, and in the church porch there are parts of a Saxon cross and some other fragments of the Saxon period. However, the church has been drastically restored (not unpleasantly) in the nineteenth century as a thirteenth-century building. Parts of the west end and parts of the chancel side walls are old.

It is a large and spacious building, bigger than the settlement around it would suggest, but Simonburn was a very large parish. The aisle slopes down to the chancel, and when it was rebuilt a south-east transeptal chapel was removed. In the nineteenth century, the chancel and the chancel arch were rebuilt. The success of the rebuilding is that the church looks and feels like a thirteenth-century one, and we may assume that the original plan was followed carefully.

Beltingham: St Cuthbert

The small village served by this church is reached only by a narrow road, but at once there is antiquity here. A discerning eye will detect a rebuilt bastle house, and there is a link with the Willimotswick late fifteenth-century defended farmhouse overlooking the south Tyne Valley. The churchyard has some very ancient yew trees. Whatever was built in the spur on the edge of a stream has been replaced by a fifteenth-century Perpendicular church, one of only two in the county (the other being at Alnwick).The windows and buttresses are of high quality, the church filled with light, and all this must be the endowment of a wealthy patron.

Three eastern windows have rustic carvings inside (*fleur-de-lys*, rabbit, flowers and a mask), and it is possible that the flanking corbels are twelfth century, but the 1884 restoration has probably removed many of the older features. It is now rectangular, divided into six bays.

Alnwick: St Michael

Alnwick, the seat of power of the Percy family, is of great importance to the county. Originating as a farm on the River Aln, the site of the castle overlooks the river. The castle is still occupied and developing; the town shows traces of the time when it was walled, lying close to the castle for its protection. The church, however, lies outside the castle above the

Simonburn: restored north side.

Simonburn: interior.

Beltingham from the south.

Alnwick from the south.

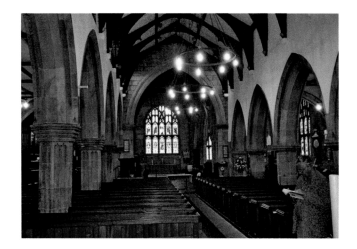

Alnwick: nave from the west.

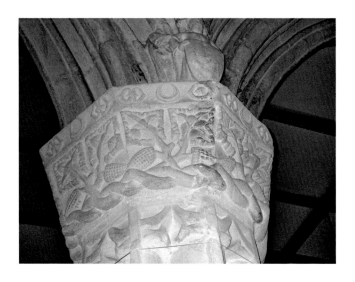

Alnwick: decorated capital,
incorporating the Percy spur.

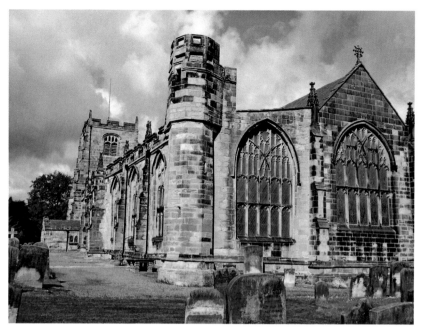

Left: Alnwick from the east.

Below: Kirkharle: east to the chancel.

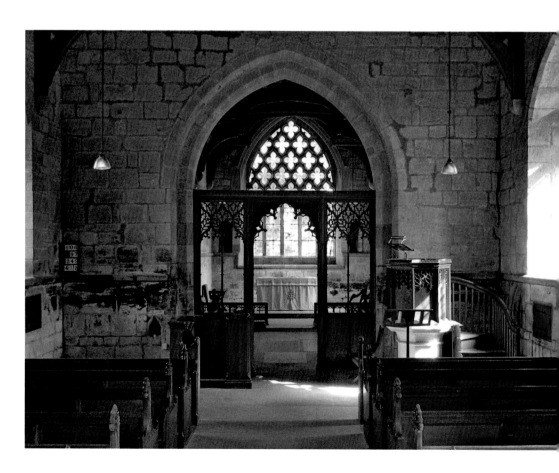

river valley and is unusual in its Perpendicular style, for the fourteenth century was not a time of church building during conflict.

The church is very big and impressive, with a nave, wide aisles of five bays, and a tower with battlements and pinnacles. The current building dates from 1464 onwards, when Henry VI gave it a port and tolls to repair the church. Other changes were to follow, linked to the development of the castle, but the early structure is basically of the Perpendicular period, fourteenth and fifteenth century.

We know that on the site before this was a chapel attached to the mother church at Lesbury, of which very small traces were seen during excavation. The presence of the Percy family is evident in the 'new' building through their symbols skillfully carved in stone.

Today the south arcade differs in style from the north. There is a stone stair turret at the south-east corner, above roof level. There have been changes since the fifteenth century; for example, the three-light west window of the nave replaces a Decorated style original.

Of the earlier chapel there is little to be seen: a small west window of the north aisle, part of a narrower aisle of 1300 before it was widened in the late fourteenth century. Excavation has shown that that the chapel had an aisle-less nave and an apsidal east end. There is a collection of old carved stone on display, some outside the porch, west. There are twenty or so twelfth- to fourteenth-century cross-slabs; there are a hammer and anvil, hunting horn, a mason's square and bows. One special feature in the church is original stained glass in a window depicting a pelican. This image, found in many churches, is based on the story that a pelican revived its chicks from death by feeding them with its own blood – a parallel of Christ's sacrifice for us. (In fact, the pelican in real life would be oiling its chick's feathers from its own.) There is good sculpture and carving: a statue of Henry VI, a martyr pierced by arrows, decoration of foliage and dragons and a hunting scene. The roof has fifteenth-century bosses.

So we have a church on a scale and refinement that is not typical of the borders, thanks to its proximity to one of the most important castles in the land. The amount of light let in by the large, decorative windows is hardly expected in a region where plunder and destruction were a common part of life.

Kirkharle: St Wilfrid

The name Harle means that it was the clearing (a 'ley') named after the Anglian Herela. It is now a developed area just off the A669, with craft workshops, a hall and farmhouse, strong evidence of medieval ploughing, a restored lake, and fame as the birthplace of the landscape planner 'Capability' Brown.

The church is built in the Decorated style of the fourteenth century, which we see at once in the windows. The church was partly rebuilt in the eighteenth century and extensively restored in 1884, but the widows in the north chancel are original; the east window has been rebuilt. The priest's door is original.

I hope that people will look at church buildings initially without looking at the book, visiting and observing, which will be better used to check my observations. Although many churches are understandably kept locked for long periods, there are others where the welcome is warm from groups of dedicated 'guides'.

ARCHITECTURAL TERMS

As far as possible, I have explained 'specialist' terms in the text, but what follows is a list of terms generally used and what they mean.

Abacus:	A flat top of a capital.
Aisle:	A space, a corridor.
Altar:	A table or slab at the east end of the church for the celebration of Holy Communion.
Apse:	A semicircular end of a chancel.
Arcade:	A row of arches supported by pillars.
Aumbry:	A cupboard or recess to hold Communion vessels.
Bay:	A space between vertical columns.
Beakhead decoration:	Norman decoration of a row of bird heads or beasts with beaks.
Billet:	Norman ornament-like blocks at regular intervals. They can be rectangular or cylindrical.
Buttress:	A vertically placed support for a wall.
Capital:	The head of a column/pillar/pier of various designs such as block, scalloped and stiff leaf.
Chancel:	An enclosed area where the service rituals take place.
Chevron:	A V-shaped motif (zigzag).
Clerestory:	Top storey of the nave walls, with windows.
Column:	An upright round-sectioned pillar with a base and capital.
Corbel:	A projecting piece of stone or wood built as a support.
Crossing:	A space where nave, transepts and chancel meet.
Dogtooth:	A decoration of small pyramids made of four meeting leaves.
Dripstone:	A projection to protect what is below it from rain.
Foliate:	Decorated with leaf patterns.
Gothic:	A period when there were pointed arches.
Hoodmould:	A covering over an arch or lintel to protect it from rain.
Jamb:	One vertical side out of two in which a doorway is set.
Keystone:	Central high stone of an arch.
Lancet:	A slender, pointed-arched window.
Lintel:	A horizontal slab that bridges an opening.
Lowside window:	Set in the side of a chancel, this window is lower than the others.

Mullion:	A vertical stone between the window openings.
Nail-head moulding:	A motif made of small repeated pyramids.
Narthex:	A vestibule or covered porch at the main entrance.
Newel:	Central stone post in a spiral staircase.
Niche:	A recess in a wall.
Ogee:	A double curve moulding.
Pediment:	A gable over a door.
Perpendicular period:	A style of building with upright tracery panels. It dates from around 1340–1530.
Pier:	A large support for an arch.
Pilaster:	A flat decoration, shallow, set as a projection against a wall.
Pillar:	A free-standing upright.
Piscina:	A basin for washing vessels, including a drain.
Plinth:	A projecting stone course at the foot of a wall.
Quoins:	Dressed corner stones, sometimes of alternate long and short lengths.
Respond:	A half-pier bonded into the wall, from which an arch springs.
Rood:	A cross or crucifix.
Rubble:	Rough coursing stones.
Sacristy:	A room in a church for sacred vessels and vestments used in services.
Slype:	Covered passage in monastic building from cloister to chapter house (Hexham).
Spandrel:	Triangular space between an arch and its containing rectangle.
String course:	Stone decorative horizontal course projecting from a wall.
Tracery:	Intersecting ribwork in a window that fills in all or part of the space, often with vertical thin shafts in the lower parts.
Transept:	Arms of the church forming the cross shape.
Transitional style:	Between two styles.
Triforium:	'Three openings': middle storey of a church.
Tympanum:	Like a drum skin, between a lintel and its covering arch or inside a pediment.
Vault:	A stone ceiling.
Voussoirs:	Wedge-shaped stones that form an arch.

INDEX